IMAGES
of America

NEW HARTFORD

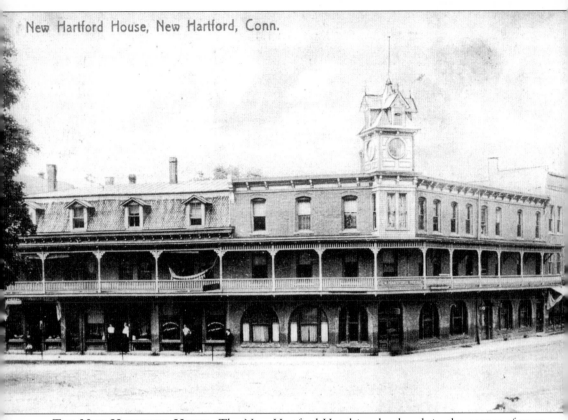

New Hartford House, New Hartford, Conn.

THE NEW HARTFORD HOTEL. The New Hartford Hotel is a landmark in the center of town on the corner of Main Street (Route 44), Bridge Street, and Central Avenue. Originally, the portion under the steeple was a two-story building called the New Hartford House (see page 77). After the white clapboard structure burned, it was replaced with this brick three-story building. The separate entity on the left was attached to the new hotel, assuming the appearance of one structure. Previously there was a house in its place (see page 77, left). The two taller buildings blocked the visibility of the clock on the building where the town hall is now (see page 77, back left). The clock steeple was removed from its original rooftop and placed on the hotel as pictured. (Courtesy Douglas E. Roberts.)

On the cover: ARNOLD LEWIS VIENOT ON SWEET MEADOW FARM IN NEPAUG. Arnold Lewis Vienot (1914–1996) began training steers to become work oxen as a very young boy. Here he is teaching five of his calves to lead wearing an ox yolk, preparing them for pulling heavy loads when they become oxen. Sweet Meadow was the Valentine-Vienot farmstead at 385 Southeast Road in Nepaug, staying in the family from the late 1800s until 1996, when Vienot passed away. (Author's collection.)

2

IMAGES
of America

NEW HARTFORD

Margaret L. Lavoie

Margaret L. Lavoie

ARCADIA

First printed in 2002.

Published by Arcadia Publishing,
an imprint of Tempus Publishing, Inc.
2A Cumberland Street
Charleston, SC 29401

Printed in Great Britain.

Library of Congress Catalog Card Number: 2002108544

For all general information contact Arcadia Publishing at:
Telephone 843-853-2070
Fax 843-853-0044
E-Mail sales@arcadiapublishing.com

For customer service and orders:
Toll-Free 1-888-313-2665

Visit us on the internet at http://www.arcadiapublishing.com

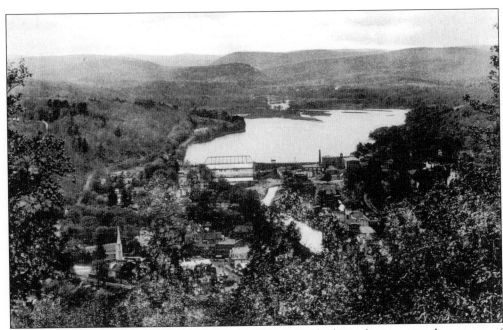

A BIRD'S-EYE VIEW OF NORTH VILLAGE. This view, looking down upon the center of North Village, shows the arrangement of buildings prior to the 1936 flood, when Greenswoods Dam was a source of water power. Cupped into the basin of the Litchfield Hills, North Village (now New Hartford) became the center of town when the Farmington River's larger source of water power overtook the numerous small mills along the Nepaug River. (Courtesy Douglas E. Roberts.)

CONTENTS

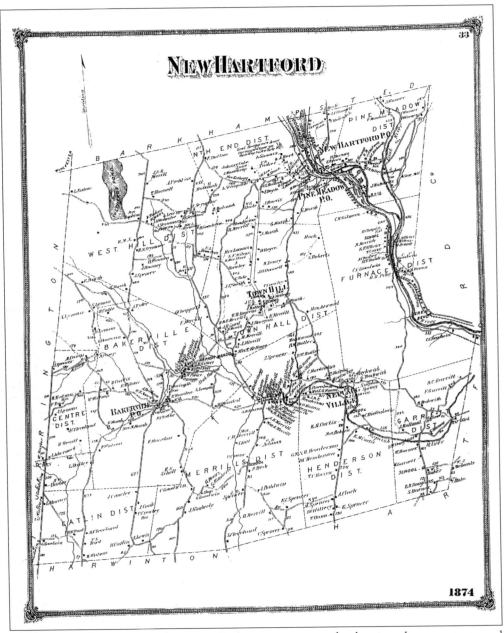

A MAP OF NEW HARTFORD, 1874. Early maps were made showing the waterways and established roads in town. The names of the roads were not listed, but to our advantage for historical research, the buildings were drawn in and the names of the owners were given. (Courtesy Gerald Colombie.)

INTRODUCTION

In 1686, the General Assembly of Connecticut feared it would loose the unoccupied land now called New Hartford, Winchester, Hartland, and the eastern part of Harwinton. The general assembly hastily made a trust with Windsor and Hartford to ensure the colonies' existence. Under the Western Grant in 1732 from the General Assembly, a deed of partition gave Hartford the right to settle the territory now called New Hartford.

Surveyors were sent from Hartford, and they chose what is now Town Hill to be the most suitable location for home lots. They set up sections on the undeveloped land one half mile in length. The roadside width was determined by the amount each taxpayer on the Hartford 1720 list paid. Each plot of land was valued at 15 shillings per acre. In 1733, the General Assembly passed an act naming the territory New Hartford. Lots were drawn to determine who would be assigned to the individual sections of land. The 182 migrating Hartford taxpayers or their heirs listed on the 1720 Hartford tax register were to follow specific conditions for a stated length of time in order to meet the qualifications enabling them to become legal owners.

The new proprietors were not satisfied with their granted pieces of property, so surveyors were sent out a second time to divide the remainder of land. Ballots were drawn again. The Hartford taxpayers were allowed to keep their parcels on Town Hill and also the new plots of land in the proposed villages.

In 1734, after horseback riders lugged in supplies over narrow and winding Indian trails, the settlers began to build livable quarters at the required minimum of 16 feet square and plow the ground. In 1742, the last parcel in the boundaries of the township was granted to the final proprietor. A meetinghouse was completed by 1749 at the top of Town Hill.

The first road in New Hartford was built through from Nepaug over the top of Town Hill. The new three miles of road allowed oxen-pulled carts and horse-drawn wagons to travel. To establish a time frame, the American Revolution was from 1775 to 1783. As the community grew, gristmills, sawmills, and small shops developed, supplying the farmers with homestead necessities. By the early 1800s, the self-supported agricultural way of life gave way to industrial changes. The location of mills shifted from Nepaug, over Jones Mountain, to the larger Farmington River area, which became known as the North Village. This area attracted clusters of people, and as North Village became more densely populated, the center of town shifted to its present location.

New Hartford appears to the onlooker to be a small, middle-class, town spread over a vast rural area. Upon forming a deeper acquaintance with the rich history of New Hartford, its community of wealthy people, gifted talents, and intellectual minds emerge from their hide-a-ways. The population—consisting of many summer homeowners, children unseen because of private schooling, and the famous limiting their interaction with others—is largely veiled from

the eyes of passersby.

Many residents have been requesting a book like this one to give accounts of New Hartford's beginnings. *Images of America: New Hartford* offers a professionally printed book, showing a composite of the town's growth clearly exposed in picture form. The thematic focus of this book begins with the time when only native Indians lived and traveled through the countryside. The development of the Colonial years is portrayed in images with descriptive captions. Each village has earned a chapter showing the common folds: people, one-room schoolhouses, churches, buildings, farms, and houses. Special interests have been incorporated throughout the book, and the ending chapter depicts some of the laborious work our forebears provided that not only sustained their lives but also contributed to the establishment of the country in which we live today in peace.

One

TOWN HILL
WHERE IT ALL BEGAN

THE TOWN HILL CHURCH. The original meetinghouse disbanded, and the first traditional church in town was erected on the summit of Town Hill. It was a Congregational church, organized in 1733 and constructed from 1740 to 1749. It was on the northeast corner of Town Hill Road (now Route 219) and Hoppen Road, just over the crest of the hill on the Bakerville side. In 1828, the church branched to North Village (now New Hartford Center). In 1848, another church branched off, building the Nepaug Congregational Church in the lower Nepaug Valley, which was then the center of town. The mother church was used for worship for 105 years, until 1854. (Courtesy Douglas E. Roberts.)

THE CHURCH THAT STABBED ITSELF. With the two new Congregational churches, the original church on the top of Town Hill closed and was left vacant. Lacking maintenance, the structure had weakened. A strong gale of wind blew the steeple off, causing it to fall point first, through the church roof. That is how the name "the church that stabbed itself" came down through history. The building was taken down in 1859. Two monuments and the church bell were placed for display where the church foundation had lain (see page 11). (Courtesy Barbara Goff.)

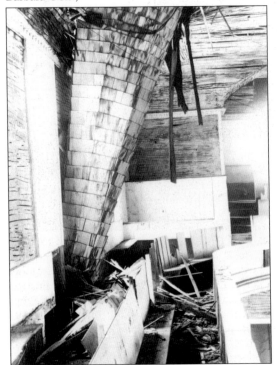

THE CHURCH STEEPLE PLUNGES. A high gale of wind blew across Town Hill in the middle 1800s, strong enough to flip over the cone shaped steeple of the Congregational church. The steeple plunged, point first, through the roof and ceiling, stopping abruptly on a church pew in the balcony. From this view, the wood shingles on the steeple appear to be fairly undisturbed, but the building was badly damaged. The church was taken down in 1859. (Courtesy Charles William Anderson.)

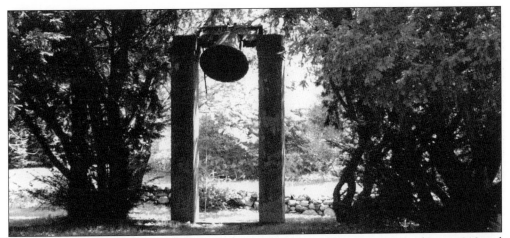

THE BELL ON TOWN HILL. On the southern crest of Town Hill at the corner of Route 219 and Hoppen Road is the bell of the first church built in New Hartford. It has been erected as a monument in memory of the first settlers of the town. There are also two cement monuments. One reads (in capital letters), "On this Plot was raised in 1739 the first meetinghouse of New Hartford, and on these very foundations the second church was built in 1829. After 1854 it was no longer used as a place of worship and was finally removed in 1929. For one hundred and fifteen years four pastors ministered here to the townspeople until these turned more and more from agriculture to manufacture and made their homes in the adjacent valleys north and south." Also engraved into the monument are names of men who served the church: Reverend Jonathan Marsh 1739–1794, Reverend Edward D. Griffin 1795–1801, Reverend Amasa Jerome 1802–1813, and Reverend Cyrus Yale 1814–1854. (Courtesy Margaret (Vienot) Lavoie)

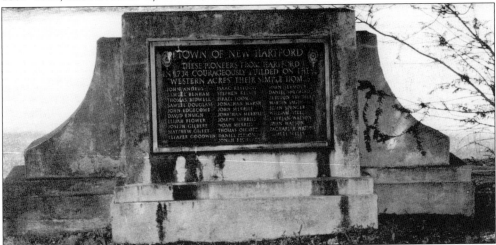

A PLAQUE ON THE SITE OF THE FIRST CHURCH. This plaque, located at the site of the first church in New Hartford, reads (in capital letters), "Town of New Hartford. These pioneers from Hartford in 1734 courageously builded on these 'Western Acres' their simple homes. John Andrus, Samuel Benham, Thomas Bidwell, Samuel Douglass, John Edgecomb, David Ensign, Elijah Flower, Joseph Gilbert, Matthew Gillet, Eleazer Goodwin, Isaac Kellogg, Stephen Kelsey, Israel Loomis, Jonathan Marsh, John Merrill, Jonathan Merrill, Joseph Merrill, Noah Merrill, Thomas Olcott, Daniel Persons, Jon H. Richards, John Seymour, Daniel Shepherd, Zebulon Shepherd, Martin Smith, John Spencer, William Steel, Cyprian Watson, John Watson, Zacharih Watson, Samuel Wells." (Author's collection.)

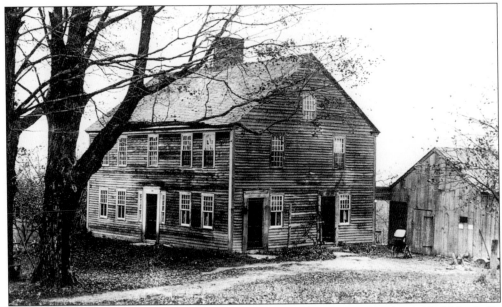

THE ASHBEL MARSH PLACE. The Marsh house was built on Town Hill by Ashbel Marsh Sr. in 1800. The Marsh family was among the early settlers of New Hartford. This estate was named Thirteen Maples. The large center chimney and the five bedroom windows across the front of the second story give clues to the size of the house. Note the baby carriage in the yard between the two buildings. (Courtesy Douglas E. Roberts.)

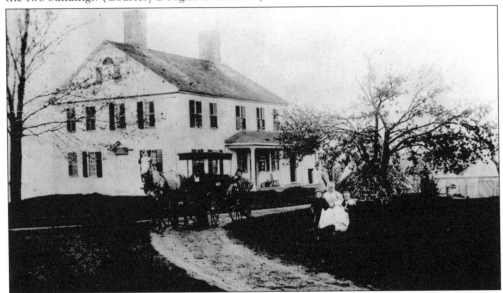

THE RIELY HOUSE. Still standing on the crest of the northern side of Town Hill on Route 219 is the magnificently remodeled version of this house. The estate is situated on the west side of the road, with the front door and circular driveway facing the sunny south side. The residence is now referred to as the Riely House, after Mr. Riely, his wife, Mary, two daughters, and a son who lived there in the 1900s. For her husband's profession, Mary Riely bought a factory that Mr. Riley presided over. The family later moved to Vermont. (Courtesy Charles William Anderson.)

Two

NEPAUG

ONCE THE CENTER OF

NEW HARTFORD

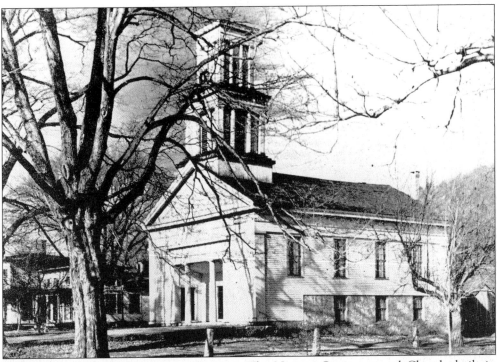

THE NEPAUG CONGREGATIONAL CHURCH. The Nepaug Congregational Church, built in 1848, was a branch of the Town Hill church. It was built in the center of Nepaug on the north side of the Litchfield Turnpike (now Route 202), with the Nepaug River separating it from the Yellow Mountain, which forms a picturesque background. The church once had a driveway that circled it. There was an open carriage house in the back, running parallel with the road. Note the stone hitching posts along the driveway. The parsonage is the Italianate-style house on the left. It was later demolished so that a parking lot could be built in its place. (Courtesy Charles William Anderson.)

DONNA MERRILL. The Merrill District in Nepaug had a schoolhouse named Merrill School on South Road near the corner of Sabolcik Road. Donna Merrill, the teacher shown here, was from one of the Merrill families in Nepaug. (Three spellings of the last name have surfaced in old papers and signatures of people bearing the name.) Donna Merrill was believed to have moved to Longview, Washington, later in life. (Courtesy George Ganung.)

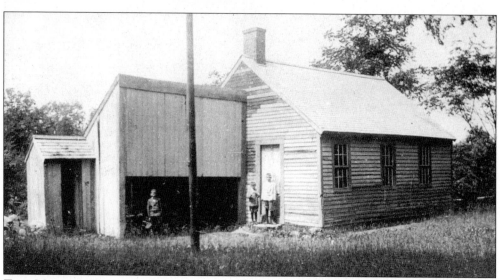

THE MERRILL DISTRICT SCHOOLHOUSE. The Merrill District School was a one-room schoolhouse, a Cape-style building with a stone foundation. The woodshed (center) joined the attached privy (left). The building is still located on South Road in Nepaug near the old Blakie apple orchard, a stone's throw from the dirt road called Sabolcik Road, and is a private home. The woodshed has been changed to Cape-style living quarters, with a front door and two windows facing the road, and the outhouse has been removed. Another brick chimney has been added to the north end of the house. The home is landscaped neatly with sparse shrubs and adorned with tall trees. (Courtesy Charles William Anderson.)

THE NEPAUG FIREHOUSE. The Nepaug Station still stands near the junction of South Road and the Litchfield Turnpike (now Route 202). For reference, the culvert of Route 202 can be seen just to the right of the building. The South End Volunteer Fire Department, near Antolini School, was the result of a merger of the Nepaug Fire Department and the Bakerville Fire Department. (Author's collection.)

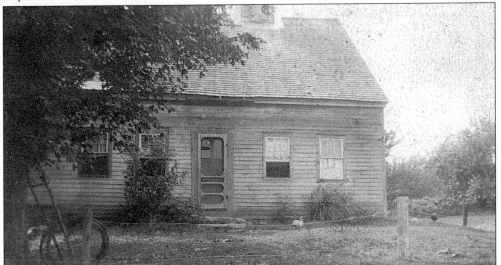

A SPENCER HOUSE. One of the first home lots in New Hartford, at 337 Southeast Road in Nepaug, was built in 1720. The Hartford surveyors granted Jared Spencer the property at the second division of parcels. In 1740, Spencer gave the land on both sides of the road to his son John. In 1749, Jared Spencer then bought 146 acres to the north. He left that property to his son Nathaniel. Milton Spencer owned the property in 1852, and M.S. Spencer, possibly the same person, in 1874. The road was first called Seventh Highway because it was the seventh road running in north-to-south parallels, starting with number one near Torrington. The road was later called Spencer Road and, in the late 1950s, it officially acquired the name Southeast Road. It is believed that the farm was sold to a Hessian soldier who fought in the Revolutionary War and decided not to return to Germany. Howard H. and Lena Spencer owned it in the 1900s. Howard graduated from Collinsville High School on June 17, 1904, while Harlow Godard was principal. He was a teacher and a Connecticut state representative. Joseph Nedelka (1948–2000) and his wife, Donna, bought the house in 1971. They sold it to Whitney Jennison in 1985, who in turn sold to Patsie Keene and her husband, Richard Droller. (Author's collection.)

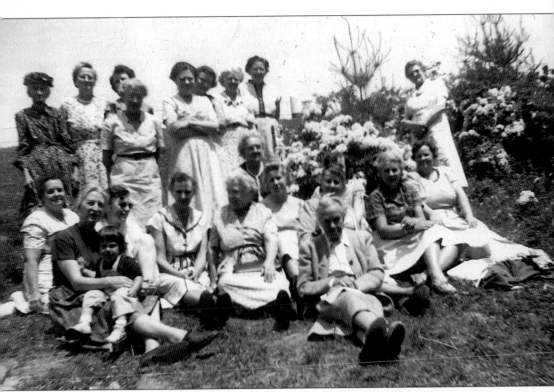

THE WOMEN OF THE NEPAUG CHURCH. The women of the Nepaug Church were on an outing in 1953 to one of their many socials. They are posing along a roadside laced with flowers. From left to right are the following: (seated) Blanche Chamberlain, Mildred Loveland holding Patty Gahagan, Julia Goodwin, Bertha Healey, Edith Goodwin, Addie Barnes, Lillian Goodwin, three unidentified women, Doris Goodwin, and Sara Peyre; (standing) ? Napey, Margaret Johnson, three unidentified women, Helen Hall, unidentified, Eunice Barns, and ? Douglass. (Courtesy Janet W. [Hall] Lavoie.)

THE NEPAUG POST OFFICE. The Nepaug Post Office building (left), with a white picket fence, is of Italianate design. It was established in 1829 under the name New Hartford Center. In 1839, James F. Henderson, the first owner of Henderson Manufacturing Company, constructed the building as a house with a smokehouse, several fireplaces, a Dutch over and butler quarters. The right rear was used for the post office, and the side door facing east still holds the mail slot. At one time mail was delivered only to people on the main roads with a star route address. They held the mail until their neighbors living on the side roads came to pick it up. Later, the rural route system was extended to incorporate the more distant country roads. The Nepaug Post Office has long been closed, and the mail is now handled by the New Hartford Post Office, in the center of town. Walt Richards and his wife, Doris, ran a gas station in the next building, with just the roof peak showing. The gas station became the gathering place for the local men, who often told tales of the Nepash Indians. The Richards owned and lived in the house that once had the post office. More recently, their sister-in-law Maggie Nevin became the owner. (Courtesy Charles William Anderson.)

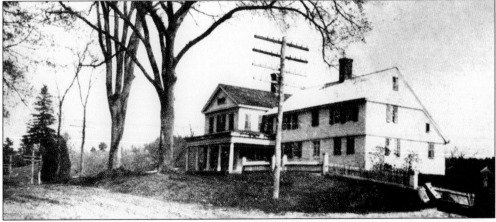

THE INN IN THE CENTER OF NEPAUG. The inn in the center of Nepaug was built in the early days of New Hartford. The original saltbox portion of the building (right) was the inn. Later, an addition was built on east side (left) as the family's home. Col. George Kellogg (1863–1952) owned the estate and ran the inn, using the first floor, which housed a bar and 30 round tables with chairs, as a gathering room. The inn was located on the main road of Nepaug. The Litchfield Turnpike was the direct stagecoach route from Hartford to the county seat in Litchfield. In relating the inn's rich history, Kellogg often pointed out the two bullet holes, one in the bar and the other in a wall. To the dismay of many local people, the inn was dismantled piece by piece in the 1950s and relocated near the Connecticut shore. (Courtesy Charles William Anderson.)

COL. GEORGE KELLOGG. Col. George Kellogg (1863–1952) was born in Nepaug, where he lived all 89 years. He lived in the inn in the center of Nepaug (see page 17), which he owned and operated. Located on the Litchfield Turnpike (now Route 202) at the corner of South Road, the inn was on the direct stagecoach route from Hartford to the county seat in Litchfield. Kellogg served a term in the Connecticut legislature as a representative. He married Sara Baldwin, and after her death, he married Grace Edwards, a minister of the Nepaug Congregational Church. (Courtesy George Ganung.)

SARA KELLOGG. Sara (Baldwin) Kellogg was the first wife of Col. George Kellogg. The couple lived in the center of Nepaug at the corner of the Litchfield Turnpike (now Route 202) and South Road. They owned and operated the inn. Sara died *c.* 1926. (Courtesy George Ganung.)

GRACE KELLOGG. Grace (Edwards) Kellogg was the second wife of Col. George Kellogg. She was raised in Sayville, Long Island, and came to Hartford in 1903 to attend the Hartford School of Religious Pedagogy. She filled in for an ill pastor at the Nepaug Congregational Church. The minister was unable to return. After her graduation from the school, she became the pastor and lived in the parsonage next door. In 1911, she was ordained a minister. She was made a voter and immediately, to her surprise, she was nominated as a candidate for the state legislature. Her deacons advised her to leave the matter up to God, and as fate would have it, she was elected. Grace (Edwards) Kellogg is a great, great aunt of Nepaug resident H.R. Edwards, who lives on Carpenter Road with his wife, Jan (Lockwood) Edwards. (Courtesy George Ganung.)

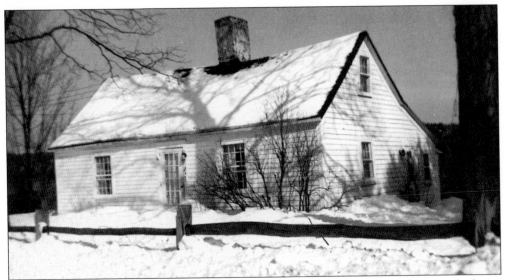

THE HALL HOME. This Nepaug Cape-style house, built in the early 1700s, became the home of Harrison and Helen (Sjoblad) Hall in 1951. Located at 62 Southeast Road, the farmhouse has a room-sized stone chimney with two working fireplaces. The granite fireplace in the living room has a Dutch oven and a warming oven. A rear addition includes wide windows, affording a beautiful view of the Nepaug River. A hand-placed stone dam crossing the water provides a peaceful waterfall, which flows toward the nearby Nepaug Reservoir. The house is being kept in its original, quaint style by the present owners. (Courtesy Janet W. [Hall] Lavoie.)

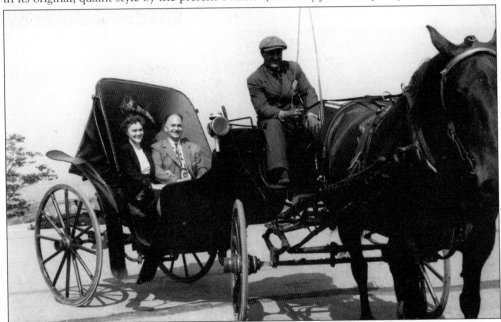

HARRISON AND HELEN HALL. Harrison R. Hall Jr. and Helen (Sjoblad) Hall made their home in two different New Hartford houses: first, at Old Well near the center of town and then in Nepaug at the Cape farmhouse at 62 Southeast Road. They are shown enjoying a carriage ride through the city of Montreal, Canada. Harrison Hall was fond of the French language and French customs he experience while living in Europe. (Courtesy Janet W. [Hall] Lavoie.)

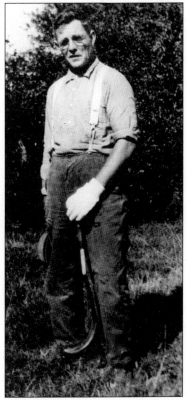

ART SPENCER. Wearing his white cotton work gloves and holding a long-handled sickle, Art Spencer takes a break from his chores on his farm at the corner of Hayward and South Roads in Nepaug. Spencer was noted for having the first telephone in town. At the time, telephone service was available only to customers who installed their own telephone poles. The Spencers were also the first to have gas lights on their farm. Unfortunately, Art Spencer suffered severe burns to his leg, an injury that eventually led to his death. The Spencer farmhouse was later known as the main house at Holiday Farm. A weathy hotelier named Mr. Blakie lived there in the 1900s and ran a sideline business growing apples, raising chickens, and producing eggs to sell wholesale to his hotels in New York. (Courtesy George Ganung.)

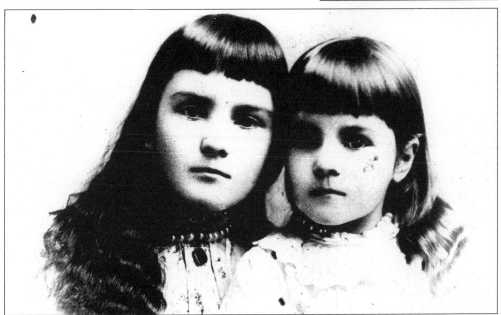

THE SPENCER SISTERS. Clara (left) and Carrie Spencer were the daughters of Henry and Eva Spencer of Nepaug. Carrie lived near the top of Whig Hill, on the south side just above the middle bridge over the Nepaug River. She and a nephew, Steve Spencer (1900–1986), lived there in their later years. (Courtesy George Ganung.)

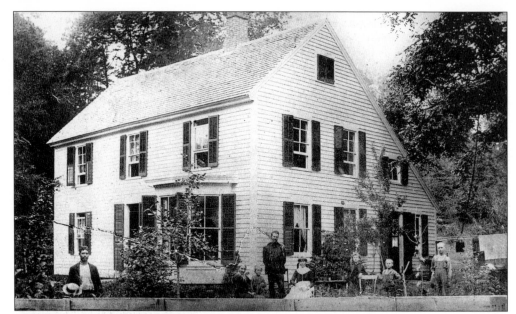

THE MASON HOMESTEAD. This charming saltbox-style home still stands on the northwest corner of Peck Lane (now Stedman Road) and Steele Road in Nepaug. It was the home of Charles Mason (1844–1929). In later generations, the Mason homestead was on the crest of Whig Hill. From left to right are Tom Parmele; Sara Ann Taylor, the grandmother, holding infant George; Luke H. Mason, the father; Jane Mason, the mother; Cora Mason (Barden), a daughter; Charles Mason, a son, and Ruben Mason, also a son. (Courtesy H.R. Edwards.)

JOHN MASON. John Chauncey Mason was born on November 8, 1820. He was the son of Peter Mason, who died at age 62 on October 11, 1841, and Mercy (Case) Mason, who lived to be 98 years old and died on August 29, 1883. His parents were both buried in the Old Nepaug Cemetery. He bought a farm in Mansfield known as the Dorset Place, which descendant Ada Burdick identified as the Mason Homestead and Wagon Works. He married Nancy Adelia Alderman (1824–1901), and they had three sons: Charlie John Mason (1844–1929), who ran Wagon Works in Mansfield; Lafayette Stephen Mason (1846–1925), who lived in Nepaug all his life; and Luke Henry Mason (1848–1929), who lived in Nepaug, married Lucrecia Jane Parmele on February 10, 1871, and had four children—Ruben, Charles, George, and Cora. John Chauncey and Nancy Adelia (Alderman) Mason were divorced on July 20, 1868, and on May 11, 1878, at age 58, John married Jennie Allen Browning (1848–1919), with whom he had two children: Willard Ernest Mason (1879–1959) and Christie Mason. John died on January 17, 1915, and was buried in Storrs. (Courtesy H.R. Edwards.)

THE BARDEN-MASON WEDDING. The marriage of Cora Mason to Elmore Franklin Barden was held on March 25, 1895. Cora was the daughter of Luke Henry Mason (1848–1929) and Jane (Parmele) Mason (1853–1928.) of Nepaug. Note her small waistline, representative of the times when tightly binding undergarments were in style. Her daughter was Florence (Barden) Edwards, whose children are Hal Rodney Edwards and James Edwards. Hal Rodney (H.R.) Edwards, a historian, still resides in Nepaug, at the base of Yellow Mountain, and is married to Jan (Lockwood) Edwards, who grew up just over the town line in Burlington at the end of South Road. (Courtesy H.R. Edwards.)

THE RACETRACK DRIVER. Elmore Franklin Barden was a farmer and a racetrack driver. His brother was Herbert Barden, and his mother was of the Fox family. His maternal grandmother was Jane (Parmele) Mason (1853–1928) and his maternal grandfather was Luke Henry Mason (1848–1929) of Nepaug. As a young man, Elmore Barden was a racetrack driver at Cherry Park Race Track on Lovely Street (Route 177), in Avon. At the track, he drove horses and sulkies. He was a stagecoach driver and had a farm in Windsor for a few years. Before marrying Cora Mason (above), he had a son with his former wife. (Courtesy H.R. Edwards.)

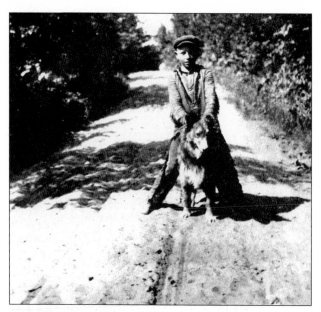

A Boy's Best Friend. Robert Stedman (1898–1973) poses with his dog, as though riding a pony, on Peck Lane (now Stedman Road). He married Edith Smith, and the couple's family included Dorothy (Peasley) LeSieur, Edith's daughter from her first marriage; Roberta (Stedman) LaPlante; Earl Stedman; and Henry Weidner, whom they brought up as one of the family. (Courtesy George Ganung.)

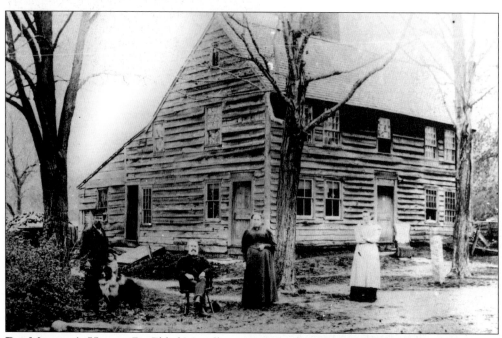

Dr. Merrill's House. Dr. Eldad Merrill, a practicing physician among the early settlers, lived in a small house on this site *c.* 1766. He handled his practice at home on Steele Road in Nepaug. In April 1775, when he marched with troops to Boston, his little dwelling burned. Isaac Loomis built this saltbox to replace it. Loomis later sold the property to Hezekiah Lewis. He in turn sold to Hobart Atwood, who owned it until his death on December 30, 1866 when it was left to Sarah Ann Atwood, Hobart's wife. She left it to Ernest Atwood, who died in 1930 and left it to his daughter Bess (Atwood) Pont. Bess Pont left it to her husband, Clarence Pont, who sold the home to the Crum family *c.* 1951. The Crums transferred it to Mrs. Willard, a schoolteacher, who then sold it to the Lindells, the present owners. (Courtesy the Lindells.)

CHARLES SMITH. Charles Smith was born in 1866 and lived in Nepaug until his death in 1954. In his adulthood, he made his homestead on Steele Road east of Stedman Road in Nepaug. The house and barn are still on the south side of the road near a small pond. In the 1900s, the farm was known as Mill Stream Farm, and a newer dairy barn was built. Smith married Lillian White of Clarks Summit, Pennsylvania, and later moved to Peck Lane (now Stedman Road). (Courtesy George Ganung.)

LILLIAN WHITE. Lillian White (1862–1931) of Clarks Summit, Pennsylvania, was the bride of Charles Smith (1866–1954). The couple raised their family in the Smith Place on Steele Road and later moved to Peck Lane. (Courtesy George Ganung.)

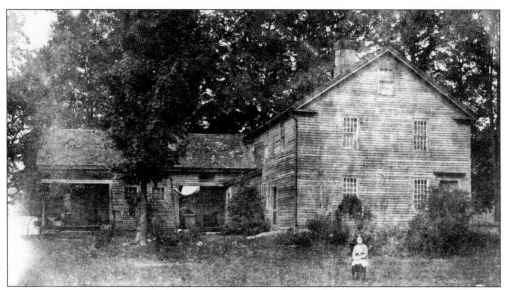

THE SMITH PLACE. Charles Smith and his wife, Lillian (White) Smith, made their home on the south side of Steele Road just east of Stedman Road in Nepaug. Known as Mill Stream Farm, the property has a stream on the west side that is dammed, creating a small pond. In the foreground of this *c.* 1910 photograph is Florence (Smith) Follert, one of the Smith daughters, who was born in 1904 and still lives on Stedman Road. The residence (above) is now under new ownership. The old barn has been transformed into a guesthouse and a new modern barn for cattle stands behind the pond. (Courtesy George Ganung.)

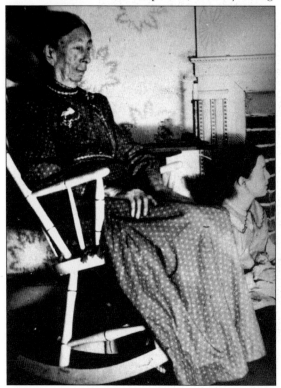

TWO GENERATIONS. Inside the Stedman Road house, Abigail (Cowles) Smith (1826–1925), a near centenarian of Nepaug, rocks near the cozy fireplace. Her granddaughter Florence (Smith) Follert (1904–1989) sits on the floor near her. (Courtesy George Ganung.)

FLORENCE (SMITH) GANUNG. Florence Rose (Smith) Ganung, daughter of Abigail and Hiram Smith, poses *c.* 1870 in her dress clothes. She was the sister of Charles Smith (1866–1954) of Steele Road, Ida Smith, and George Smith. (Courtesy George Ganung.)

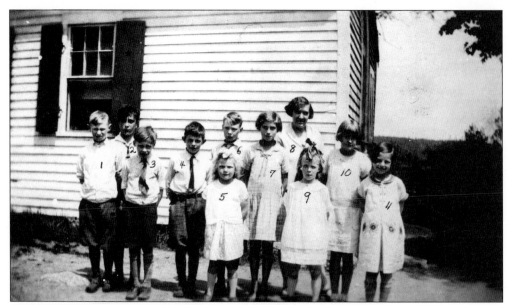

THE SOUTHEAST SCHOOL. The Southeast School was a one-room schoolhouse on Southeast Road in the Henderson District of Nepaug. It was situated just north of the Hall house (see page 20) on the river side of the road near the lower side of the brook that crosses the road. From left to right are unidentified, Michael Dezzani, Kenneth Anderson, Earl Stedman, ? Sterling, Charles Anderson, Roberta Stedman, teacher Addie Barnes, Ida Sterling, Hazel McDowell, and unidentified. The schoolhouse burned in 1970. (Courtesy H.R. Edwards.)

SARA (TAYLOR) PARMELE. Sara Ann (Taylor) Parmele was born on January 6, 1827, and was believed to have been from Rondile, Illinois. She was the daughter of Abner and Sally B. Taylor and the mother of Jane (Parmele) Mason (mentioned on page 23). (Courtesy H.R. Edwards.)

Three
THE NEPAUG RESERVOIR AND DAM

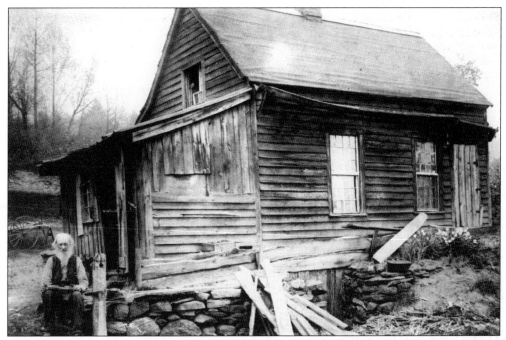

THE COBB PLACE. Art Cobb sits near his home, which was once located under the reservoir. He was one of the last American Indians to live in the area. His long white beard and European features reveal the strong mixture of blood he inherited. He had three daughters named Patience, Mary Matilda, known as "Til", and Hattie, known as "Hat." (Hattie died tragically in the Nepaug State Forest fire, and her remains were never found.) It has been said that the Cobb family lived in many places, including near the bridge in Satan's Kingdom, under the Nepaug Reservoir, at the top of Whig Hill in Nepaug, and on Nepaug Road in Burlington. (Courtesy Clair W. Wilder.)

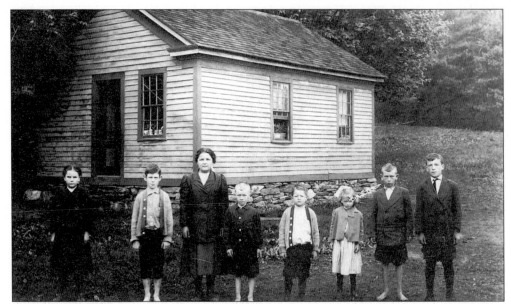

THE GARRETT SCHOOL. The community under the reservoir included the Garrett School on Douglas Road. It was on the intersection leading toward Collinsville. The school was located near the Garrett homestead, from which it got its name, on the west side of the road at the base of Garrett Mountain, between Douglass Road and Southeast Road. The young girl in the white skirt is Margaret Napey. To the right of her, barefoot, is John Napey. The school was removed for the Nepaug Reservoir Project. The Napey family moved to Nepaug Center, two houses east of the Nepaug Church. (Courtesy H.R. Edwards.)

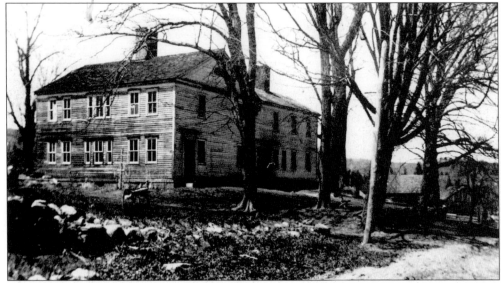

THE GARRETT PLACE. The Garrett homestead stood on the west side of Douglass Road, not far from Weston Barnes's home, under the Nepaug Reservoir. The house was large even for the 1800s. Mr. Garrett must have been a prominent man in the area because the mountain to the west, which acted as a natural barrier for the new reservoir, earned the name Garrett Mountain. Garrett Mountain is now bound on the east by the Nepaug Reservoir and on the west by Southeast Road in Nepaug. (Courtesy George Ganung.)

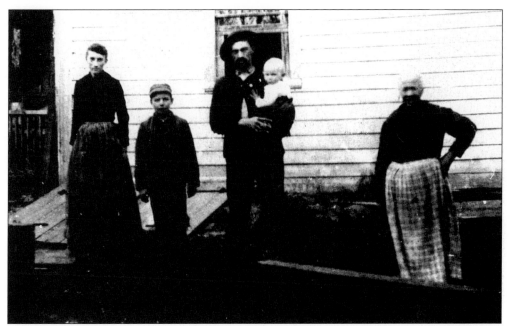

THE NAPEY FAMILY. A closeup of the Napey place under the reservoir shows Mr. and Mrs. Lou Napey and their children. The boy between the parents is assumed to be the eldest, John, and the baby held by the father is believed to be Elizabeth, who married a Mr. Paten from Maryland. If this is the case, the other children, George, Henry, Mary, and Anna, had not yet been born. The woman on the right is unidentified. (Courtesy George Ganung.)

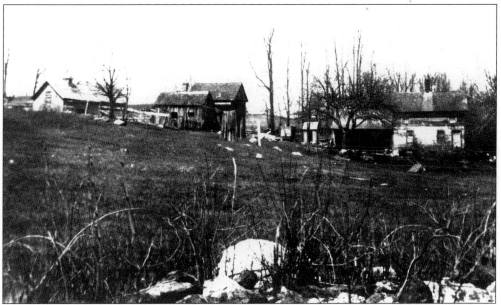

THE NAPEY PLACE. The Napeys lived on this farm under the reservoir until the commencement of the building of the Nepaug dam. Then they were relocated, along with the residents of 21 other homes. The Napeys moved to Litchfield Turnpike (now Route 202) in the center of Nepaug just two houses downriver and east of the Congregational church. (Courtesy George Ganung.)

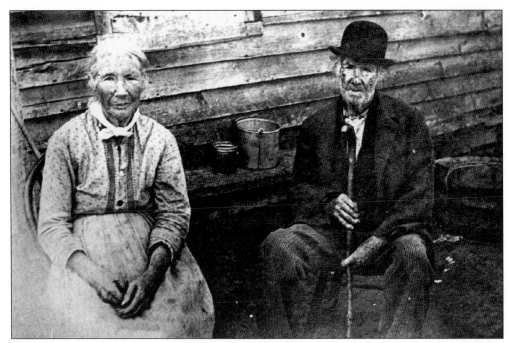

THE ELWELLS. Laurie (Elwell) Warner and her father, John Elwell, sit outside the house. The father holds a walking cane, indicating his age. The Elwells lived where the Nepaug State Forest is today. They were American Indians, closely connected with the Cobb family, who lived under the reservoir. (Courtesy H.R Edwards.)

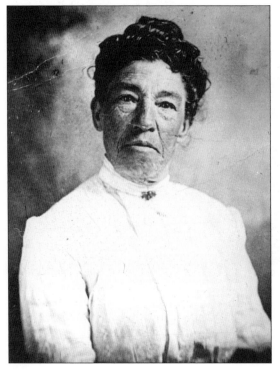

MARY (COBB) MERRILL. "Old Til" was the nickname for Mary Matilda (Cobb) Merrill. She was a daughter of Art Cobb, an American Indian. Beatrice (Valentine) Osden tells of Til, who lived next door to the Valentines. The historic house still stands on the town line in Burlington on Nepaug Road. Harry Spencer of Southeast Road owned the house for some years. After the Cobbs, Lewis and Martha Lockwood and family lived there for about 25 years during the mid-1900s. A Nepaug Cemetery worker, Stephen Spencer, stated that he was instructed to bury Old Til on the sidelines of the new cemetery in Nepaug, with the paupers, c. 1930. The is no stone or record for her. (Courtesy H.R. Edward.)

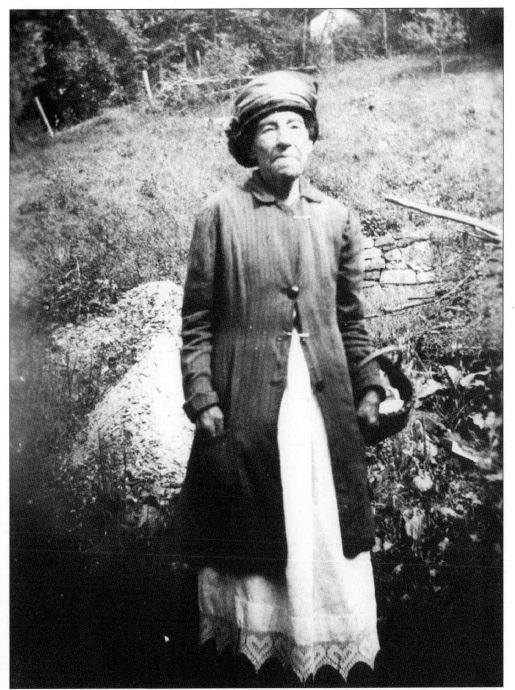

PATIENCE COBB. Patience Cobb, a daughter of Art Cobb, lived with her sister Mary Matilda "Til." The sisters took in wash and wove baskets for their means of support. At one time they lived on the north end of where the Nepaug Reservoir is now. The white apron adorned with scalloped lace was handmade by Florence (Eaton) Valentine, the wife of Francis P. "Rock" Valentine, a neighbor on the Nepaug-Burlington town line. (Courtesy H.R. Edwards.)

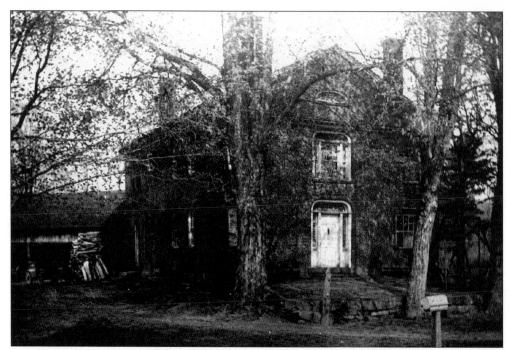

THE HOME OF WESTON BARNES. This *c.* 1912 photograph depicts the tidy brick home of Weston Barnes. The carriage house to the left is sheltering a horse carriage, and near the buildings, stands a motor-driven vehicle of the era. It must have been a sad time for owner Weston Barnes and family as they were forced to give this homestead up to the Water Bureau for the construction of the new Nepaug Reservoir. This is one of the 22 houses now called an under-the-reservoir home. (Courtesy Clair W. Wilder.)

THE BARNES PLACE. This photograph of the Weston Barnes place, which was located under the reservoir close to the Nepaug River, was taken *c.* 1912. The bridge passing over the river is on Douglass Road, now a private maintenance road owned by the Metropolitan District Commission. (Courtesy Cubby.)

THE CARDING MILL. The fertile valley, which now lies under the Nepaug Reservoir, was once a village of its own. One of the businesses was a carding mill where owner Isaac Barnes removed seeds and other foreign matter from the newly sheered sheep's wool and formed it into a web of carded wool. Isaac Barnes owned the farm on Douglass Road, which was previously owned by Weston Barnes. (Courtesy George Ganung.)

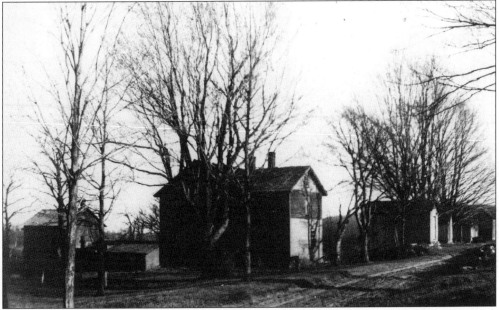

THE BAKER PLACE. The Baker Place was once part of the village under the Nepaug Reservoir. One story told is that Mr. Baker, upset with the small price offered for his farm, moved to California without accepting payment for his property. (Courtesy George Ganung.)

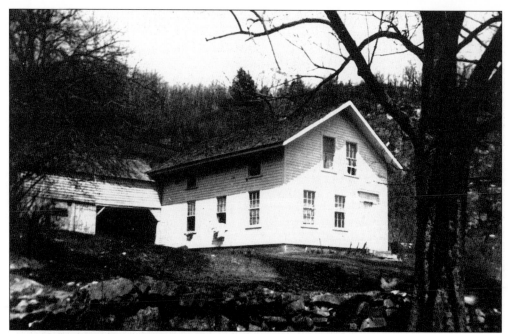

VACATED FOR THE RESERVOIR. This is one of the 22 homes that were vacated for the building of the Nepaug Reservoir. Residences within the water flow line, as well as some close to the proposed water's edge, could no longer be inhabited in order to ensure the purity of the city drinking water. (Courtesy George Ganung.)

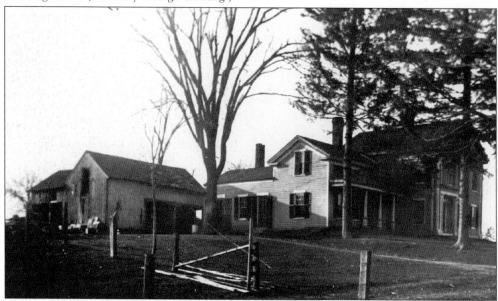

REMOVED FOR THE RESERVOIR. This house, with its additional ells and outbuildings, was also removed for the reservoir. The Metropolitan District Commission of Hartford cut down the trees and brush, removed all the buildings, and purified the barnyard soil of all the farms. Then the commission constructed the masonry Nepaug Dam on the northern end and the earthen Phelps Brook Dam on the southeastern side. The completed dams allowed the natural basin to hold the water between the mountains. (Courtesy George Ganung.)

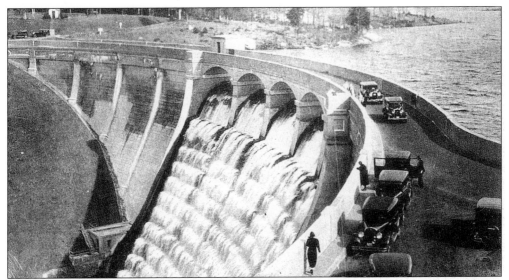

THE DAM. Constructed between 1912 and 1916, the Nepaug Dam is on the northeast end of the Nepaug Reservoir in the town of New Hartford. The Metropolitan District Commission (MDC, Water Board or Water Bureau), moved homes, farms, a church, a school, and two cemeteries to create a reservoir for supplying water to the city of Hartford. The commission bought land in the surrounding towns to provide a watershed. Before Route 202 was built, the dam provided a crossing for traveling from Torrington to Collinsville. In the first decades, the grounds were kept well groomed and were abundant with flowers. The roadway is now used for a walking trail. (Courtesy Douglas E. Roberts.)

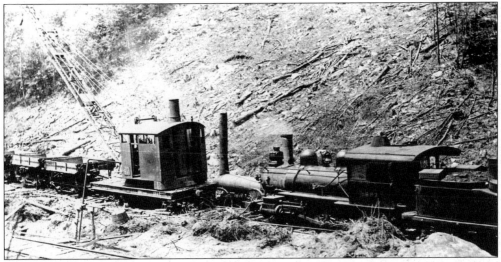

A LARGE UNDERTAKING. The building of the Nepaug Dam was one of New England's greatest engineering projects. The contractor, Fred T. Ley and Company, installed a mini railway to haul its equipment and materials to the site. Work began in 1912, under a special act of the General Assembly of Connecticut to form an additional supply of water for Hartford. The chief engineer was Caleb Mills Saville, who was just finishing engineering work on the Panama Canal when he was hired for the Nepaug project. The Saville Dam, which separates the Barkhamsted and Compensating Reservoirs in Barkhamsted, was named for Saville. (Courtesy Charles William Anderson.)

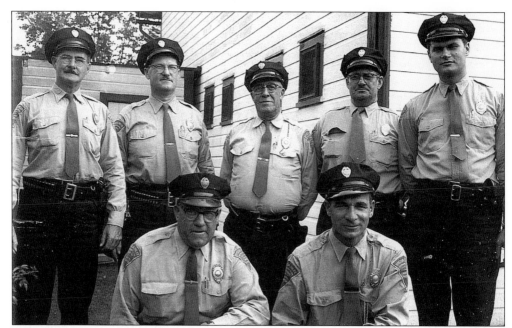

THE SPECIAL POLICE FORCE. Seven men worked as Metropolitan District special police officers in the mid-1900s. They patrolled the thousands of acres of Metropolitan District Commission watershed land in surrounding towns. Land around reservoirs must be kept pollution free. Laws are strictly enforced and effective at protecting against erosion, preventing debris from public or private use entering the waterway, and prohibiting fishermen from catching the stocked fish. From left to right are the following: (front row) Earl "Cookie" Cook and John Dondero, both of Barkhamsted; (back row) Burtrum Carrier of Torrington-Avon, Sgt. Arnold L. Vienot of Nepaug, Louis "Shep" Shephard of West Hartland, Harold C. Vienot of Nepaug (brother of Arnold), and Theodore Jaskowski of Burlington. (Author's collection.)

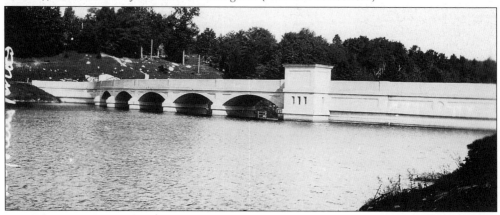

THE MASONRY DAM. The Nepaug Dam (above) is a masonry dam, approximately 600 feet long, on the north side of Nepaug Reservoir. The Phelps Dam, an earthen dam of similar length, is on the Burlington side. At the Phelps Dam, a 42-inch pipe carries the water down and under the Farmington River, through Talcott Mountain, and on to the filtration plant in West Hartford. The Nepaug Reservoir covers land in New Hartford, Canton, and Burlington and is mainly fed by the Nepaug River, Phelps Brook, and Clear Brook tributaries. It is capable of supplying 33 million gallons of water per day. (Author's collection.)

Four

THE NORTHERN
PLANTATION

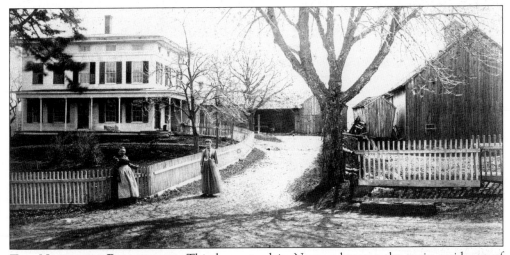

THE NORTHERN PLANTATION. This homestead in Nepaug became the main residence of Plesent and Agathe (Arnold) Valentine. It is located at 306 Southeast Road on the east side of the intersection of West Road. Because of Plesent Valentine's remarkable abilities and visionary goal, the estate has earned the title the "Northern Plantation." Andrew T. Clark Jr. began building the house in 1852 and finished it in 1855. His signature and completion date are still evident on the wall at the top of the cellar stairs. He built it out of native chestnut timber, known for its strength, and it is reported that the framing timbers still remain straight and level. After Clark's death, his heir Mary Clark sold the farm. Plesent Valentine lived here for 22 years, from 1893 to 1915. Agathe Valentine (far left) passed away in 1908. In addition to raising their five children, farming, and boarding hired hands, the Valentines successfully ran businesses in lumbering, charcoal making, farm rentals, real estate, and money mortgaging. They often hosted bountiful meals prepared by Agathe and a hired woman for people less fortunate. Dominic and Rose (Torchio) Dezzani bought the property in 1929. Then, it was converted into a two-family house for their sons Massino "Diz" and Mike and their families to live in. The sons divided the land, and in 1981, sold the house, barn, and stone garage to James and Barbara Wilson, who made the plantation quarters into a horse farm. (Author's collection.)

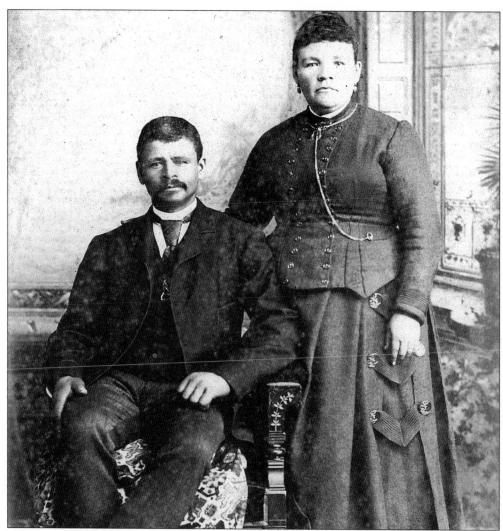

PLESENT AND AGATHE VALENTINE. Plesent Franklin Valentine (1848–1915) and Agathe Arnold (1849–1908) were married on August 5, 1874. Agathe was a professional seamstress in her homeland of Germany. Plesent left his home in Virginia at age 14. Being too young to enlist in the Confederate army, he volunteered to travel with the soldiers for a time. During the Civil War, he switched to the Union army and won recognition for doing so. He was wounded a few times and then honorably discharged from the 20th Connecticut Regiment in Hartford, according to his obituary. In Connecticut, he worked on farms until he met Agathe Arnold in Burlington. She had emigrated from Germany and was working on a farmstead saving money to sponsor her three children with the last name of Horn to come to America. Plesent, according to granddaughter Carrie (Williams) Bright, proposed marriage saying, "Within five years, I will have a farm for you." He did, and they soon owned numerous farms consisting of hundreds of acres. The Valentines were said to have owned a large portion of New Hartford, the northern part of Burlington, and part of the western side of Canton. He was a remarkable person who came from a Southern heritage as a poor boy witnessing grand living. With his natural ability and vision for his family, he became a prominent landowner. The Valentines were also well-known for their businesses in New Hartford, Burlington, and Collinsville. (Author's collection.)

WALLIE VALENTINE. Wallie Valentine, born December 26, 1874, was the eldest child of Agathe and Plesent Valentine. He passed away in early adulthood. (Author's collection.)

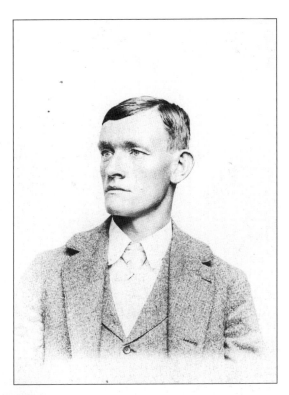

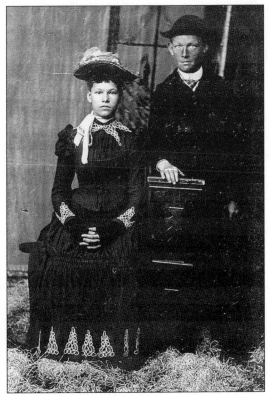

NELLIE AND WALLIE VALENTINE. Nellie Agatha Valentine (Vienot) (1876–1961) was the second eldest child of Plesent and Agathe Valentine. With her is the eldest, Wallie Valentine (1874–1922). (Author's collection.)

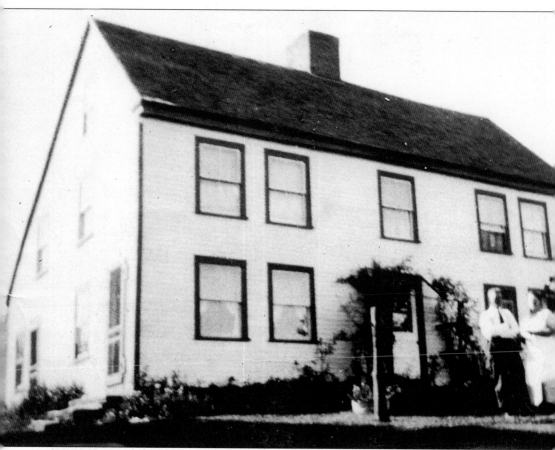

SWEET MEADOW. Known as Sweet Meadow, this saltbox house and farm at 385 Southeast Road is one of many farms that Plesent and Agathe Valentine owned. Sweet Meadow had been called the Spencer home at one time. In 1852, it was owned by S. Barnett, and in 1874, T. Bunn owned it. The Valentines lived in it for 18 years. After trips to Europe, Agathe returned with flowers, Jerusalem artichokes, linden trees, grapevines, currant bushes, and gooseberries, and planted them along the roadside garden she designed as a French garden. In 1898, their daughter Nellie Agatha and her husband, Conrad Vienot, bought Sweet Meadow and made it their home. There, they farmed, raised their six children, and lived for their remaining years. Sweet Meadow was then transferred to son Arnold L. Vienot. After his death in 1996, the farm was sold out of the family. The farm is on the Burlington town line. The saltbox and the small servants' house occupied by their daughter Bertha and her husband, Chester Surdam, burned in April 1949, leaving only the 12-foot-by-12-foot stone chimney of the main house standing. (Author's collection.)

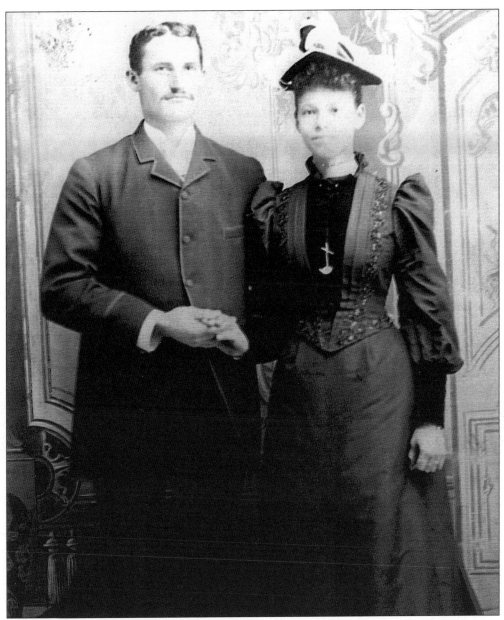

THE VALENTINE-VIENOT WEDDING. On November 24, 1892, Nellie Agatha Valentine, age 16, married Conrad Vienot, born in Gwibberville, Alsace, France. Note her 18-inch waistline. Their wedding must have been a grand affair. It was held at the Northern Plantation with elegantly printed wedding invitations and a meal to satisfy any plantation owner. Her mother, Agathe Valentine—a wonderful baker and cook, accustomed to serving large meals with all the trimmings—prepared the feast with the help of a hired women. The band that played for the reception was seated on the front roof of the house. A family story says that the drummer, a large man, got stuck in the narrow hatch leading from the third floor onto the roof. Nellie (1876–1961) and Conrad (1867–1938) Vienot had six surviving children. After the death of her mother in 1908, Nellie handled the business accounts of her father, Plesent Valentine. (Author's collection.)

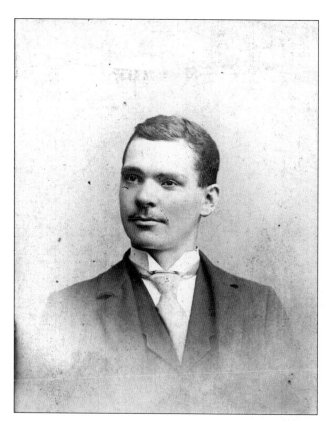

FRANCIS P. VALENTINE. Francis P. Valentine (1879–1952), known as "Rock," was a son of Plesent and Agathe Valentine. He owned the adjoining farm on South Road in Nepaug. The farm consisted of acreage on both sides of the road bordering the Burlington town line. He was known for his cranberry business. The cranberries were raised in the bog behind his house, leading toward Hayward Road. (Author's collection.)

FLORENCE VALENTINE. Florence (Eaton) Valentine of Burlington was the wife of Francis P. Valentine. The couple had four children and lived the remainder of their lives on their farm on South Road in Nepaug. Plesent "Pes" and Beatrice were their two children who survived into adulthood. (Author's collection.)

GERTRUDE AND ARTHUR WILLIAMS.
Gertrude Mary Valentine, youngest daughter of Agathe and Plesent Valentine, married Arthur Williams. They moved to Massachusetts for a short time and then made their homestead in a 1733 saltbox house on Locust Road in Harwinton. Many children lived in that household, including foster grandchildren. (Author's collection.)

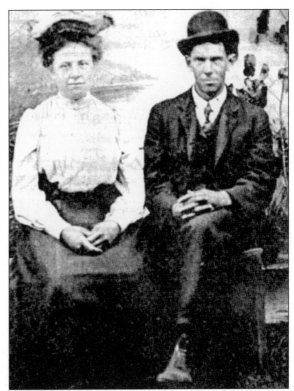

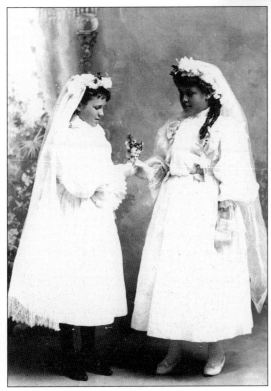

GERTRUDE MARY VALENTINE.
Gertrude Mary Valentine (right) was born March 2, 1885. She made her First Communion at St. Patrick Church in Collinsville. Many South End residents were closely connected with Collinsville because of its short distance to the village. The girl on the left is unidentified. (Author's collection.)

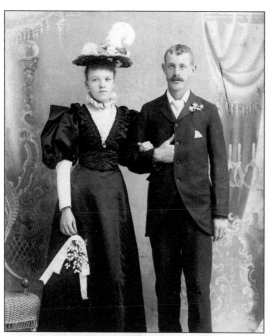

ABIGAIL AND ED KATZUNG. Abigail Valentine, the next-to-youngest child of Agathe and Plesent Valentine, was born on August 23, 1877. She is shown with her husband, Ed Katzung, on their wedding day. The Katzungs, who lived on the West Road in Nepaug, were neighbors of the Valentines. They later moved to New Road in Avon, where they raised two boys, Albert and Eddie. (Author's collection.)

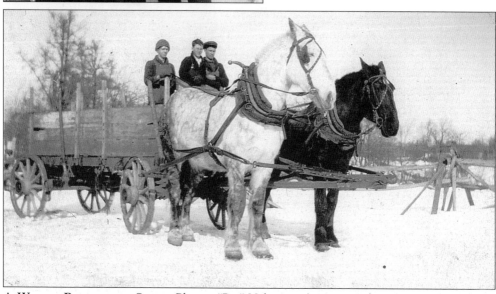

A WAGON RIDE IN THE SNOW. Plesent "Pes" Valentine (1909–1988) was a son of Francis P. "Rock" Valentine and Florence (Eaton) Valentine. He is pictured in his younger years as the driver, giving a ride to his cousin Ed Katzung (right), son of Abigail and Ed Katzung of Avon. The person in the middle is unidentified. Pes Valentine was a former president of the New Hartford Historical Society, a secretary of the South End Fire Department, and a sand painter—he made pictures inside bottles with colored sand he collected from different parts of the world. He also was a cartoonist, landscape designer, and oil painter, along with other credits. His picture can still be seen in the South End Volunteer Firehouse. He lived most of his life on South Road in Nepaug, and then he moved to 165 Gillette Road in Bakerville with his second wife, Eva (Adams) Orie Valentine. The couple also owned a home on the island of New Symerna Beach in Florida. (Author's collection.)

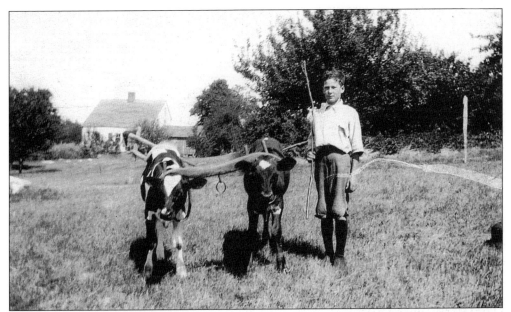

ARNOLD LEWIS VIENOT. As a young boy, Arnold Lewis Vienot (1914–1996) tended to these steers, Sammy and Jimmy, and broke them to walk with an ox yolk. He is pictured in front of an apple orchard behind the saltbox house at Sweet Meadow farm, which was owned by his parents Conrad and Nellie Agatha (Valentine) Vienot. The farm was at 385 Southeast Road in Nepaug. The house burned in 1949, and Arnold, at age 35, remodeled the garage for his family home. (Author's collection.)

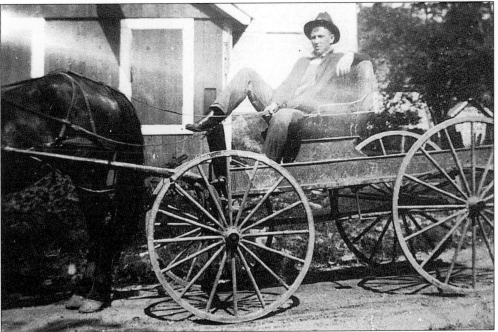

WALLIE VIENOT. Wallie A. Vienot, the eldest son of Conrad and Nellie Agatha Vienot, was a selectman of New Hartford for 25 years, from 1940 to 1965. He also supervised the town road crew. He is shown in his younger years, taking a rest on his wagon. (Author's collection.)

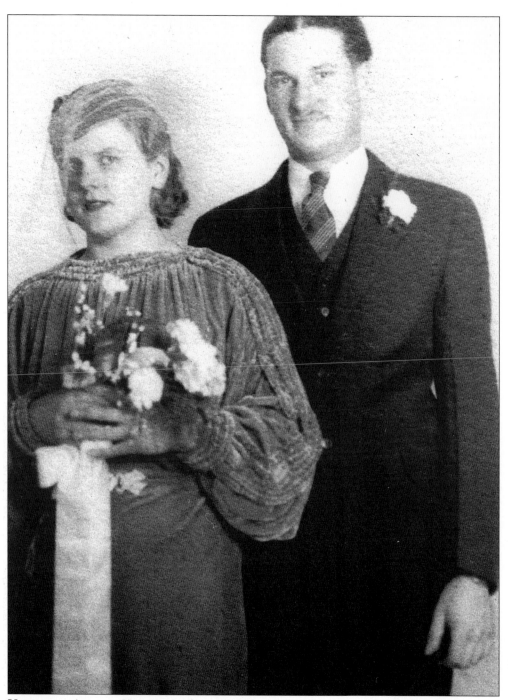

VIOLA AND ARNOLD VIENOT. In the mid-1930s, Viola M. Luntta and Arnold L. Vienot were witnesses to the wedding of Vienot's brother, Harold C. Vienot of Nepaug, and Rose A. Billadeau of Collinsville. Viola Luntta wore a purple velvet maid of honor dress. She was born in Collinsville and grew up on East Hill Road in Canton. Arnold Vienot was born and raised in Nepaug and lived on Sweet Meadow Farm on Southeast Road his entire life. Viola Luntta and Arnold Vienot were married the following year. (Author's collection.)

Five

BAKERVILLE, BAKERSVILLE, OR THE WATSON DISTRICT?

DECORATION DAY. Decoration Day originally was celebrated in honor of soldiers killed in the Civil War. In 1868, the northern states officially acknowledged the celebration day on May 5. A general order was given to strew flowers over the graves of comrades. In 1882, the name was changed to Memorial Day. The Marsh family on Maple Avenue Farm proudly displayed a U.S. flag for the center of their holiday. On the left side of the flag is Ruth Flatley, and on the right of the flag is Katherine (Bond) Marsh. The other people are unidentified. (Courtesy Bill Stafford.)

THE BAKERVILLE METHODIST CHURCH. The Bakerville Methodist Church is of Greek Revival style, which became popular in the 1830s just prior to the time the church was built in 1846. It was located where the Bakerville Firehouse on Maple Hollow Road now stands, next to the Academy school (now the Bakerville Library), on the right. The church burned on September 23, 1954, and a new church was built on Route 202, just east of the junction of Maple Hollow and East Cotton Hill Roads. (Courtesy Bakerville Library.)

THE NEW BAKERVILLE CHURCH. This Bakerville Methodist Church on Route 202, just east of Bakerville Center, replaced the church built in 1846 on Maple Hollow Road, next to the library where the old firehouse is now. The old church burned in 1954, and canvassing for a new church was started in 1956. The land was a gift from Lula Belden. The Fellowship Hall was built before the sanctuary and opened for its first service on Easter Sunday in 1958. The church building was erected and held the first Consecration Service on Sunday, December 11, 1960. This photograph was taken in 1961. (Courtesy Ralph and Judy Morse.)

REV. GEORGE SMITH. Rev. George D. Smith has been the pastor of Bakerville Methodist Church since 1970 and still leads his flock with great zeal. He was born in Florida and grew up on Long Island, New York. He graduated from Taylor University in Indiana and then earned his first master's at Hasbury Theology Seminary in Kentucky and a second master's at Princeton Theological Seminary in New Jersey. With all his degrees, he is a down-to-earth minister who had a bicycling ministry with the youth of the church for 25 years, riding 17,000 miles. He led a hiking group in the White Mountains for eight years. The church had its own volunteers who built houses at a fold in New Hampshire and in the Appalachian Mountains in West Virginia. (Courtesy Bakerville Methodist Church.)

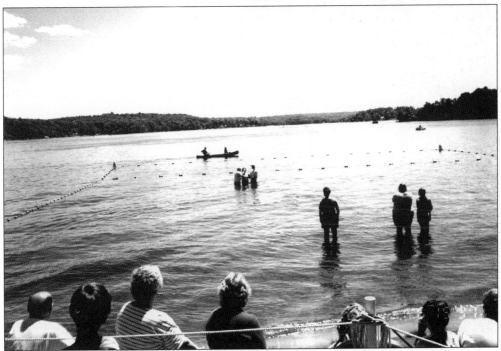

A BAKERVILLE CHURCH BAPTISM. The Bakerville Methodist Church met at Bantam Lake to perform baptisms by immersion. The ceremony was open to people ready to dedicate their lives to Christ in a public way. Rev. George D. Smith stands near the swimming ropes in the lake with an assistant ready to immerse the next person to be "baptized by water," like in the River Jordan. The three people standing near the shore are waiting their turn. (Courtesy Bakerville Methodist Church.)

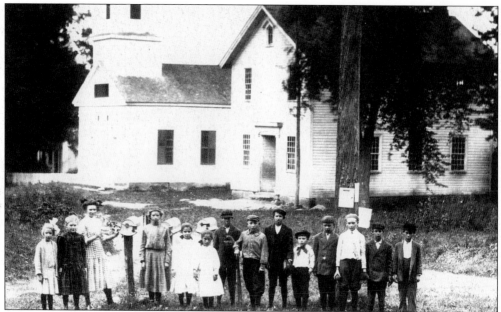

BAKERVILLE ACADEMY SCHOOLCHILDREN, 1911. The former Bakerville Academy (right), a public school, opened in 1873. Research is currently being conducted to determine the origin of the building. The academy building became the Bakerville Library after the town of New Hartford built a new facility called the Bakerville Consolidated School in 1941 for grades one through eight. The newly founded library was established with the help of Nelia Gardner White, a writer who lived at the top of Maple Hollow Hill. Her daughter, Barbara Yedlin, was also instrumental in the instituting the service and became the librarian. Ethel Jones (Bartholomew) is on the far left, with the big white bow in her hair. Warren W. Jones is the third from the right, with the white shirt. The library still stands near the intersection of Maple Hollow Road and Route 202. The Bakerville Methodist Church pictured on the left burned in 1954. (Courtesy Barbara [Jones] Goff.)

THE LITTLE RED BRICK SCHOOLHOUSE. The Little Red Brick Schoolhouse was on the southeastern corner of the island of land enclosed by the Litchfield Turnpike (now Route 202), Maple Hollow Road, and Knipe Road. The schoolhouse was replaced by the Bakerville Academy, also a public school. (Courtesy Bakerville Library.)

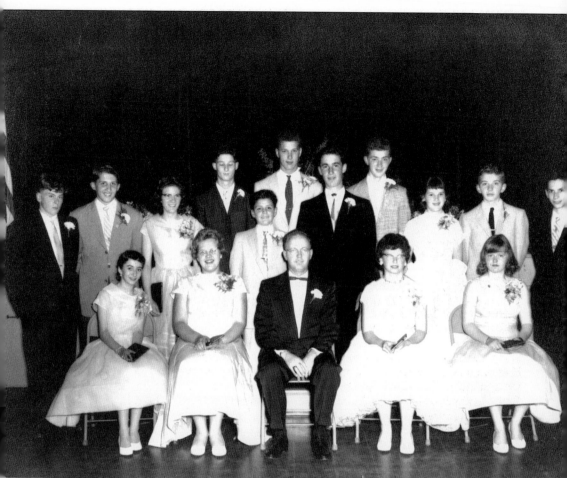

THE BAKERVILLE CONSOLIDATED SCHOOL CLASS OF 1958. This is the last class to graduate from the eighth grade at Bakerville Consolidated School and the first freshman class to go to the new Northwestern Regional No. 7 High School in Barkhamsted. From left to right are the following: (front row) Janet Hall, Jean Wesolowski, teacher William Billingham, Eileen Follert, and Marcia Kissiel; (middle row) Michael Buyak, John Panko, Margaret Vienot, William Donovan, Donald A. Dings, Shirley Richardson, George Jones, and Leon Hoden; (back row) Angelo Savanella, Donald Steeves, and Ralph C. Morse. (Author's collection.)

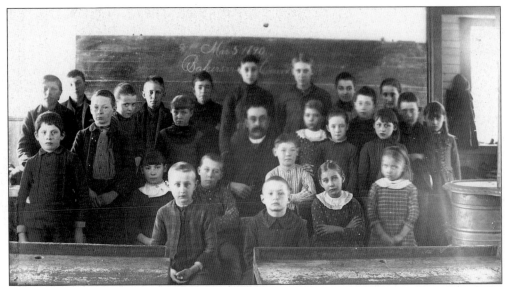

THE BAKERVILLE SCHOOL, 1890. Edgar A. Clarke, who died in 1934, was not only the teacher of this 1890 class of students but also a Bakerville postmaster. On the chalkboard is written "Bakersville," spelled with an "s." Clarke had a medical problem with his legs and therefore sat on a wheeled device, which may account for him being seated in the center. Note the wood stove on the right for heating the room. (Courtesy Bakerville Library.)

THE BAKERVILLE SCHOOL, EARLY 1900S. The Bakerville School was on Maple Hollow Road in the building that housed the library until 1941. From left to right are the following: (front row) Ernie Barella, Paul Sekulski, Mike Fusco, Willie Muckle, Albert Harrison, Floyd Harrison, Ronnie Ballard, John Phillips, and Norm Simmons; (middle row) Irene Weingart, Fred Vickers, George Phillips, Margaret Harrison, Albert Fusco, and Jeanette Stedman; (back row) Fred Clark, Joe Sekulski, Harry Whitbeck, Malcolm Sedgwick, Richie Barella, John Muckle, Frank Vickers, Elsa Muckle, Susan Muckle, and Miss Sheffield. (Courtesy Bakerville Library.)

BAKERVILLE SCHOOLGIRLS. In front of the Bakerville School on Maple Hollow Road, teacher Fern Johnson (front center) poses with the schoolgirls in 1919. In the front row are are Ethel Bartholemew (left) and Fern Johnson (right). The girls in the back row are unidentified. (Courtesy Bakerville Library.)

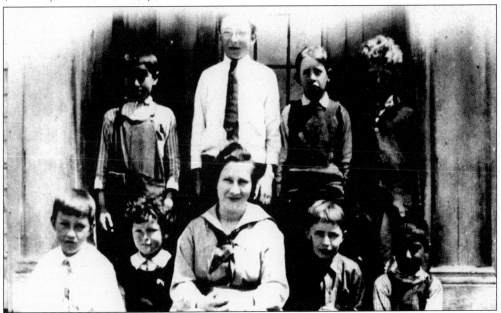

BAKERVILLE SCHOOLBOYS. In 1919, teacher Fern Johnson (front center) sits for a picture with the schoolboys at the Bakerville School on Maple Hollow Road. From left to right are the following: (front row) Billy Goodwin, unidentified, Irv Goodwin, and Nonzio DeMartino; (back row) Michael DeMartino, William Phillpis, Lyman ? , and Carl Snyder. (Courtesy Bakerville Library.)

THE FIRST HOUSE IN BAKERFIELD. This house, now referred to as the Leonard House, was the John Cyprian Watson House built *c.* 1740. It is believed to be the first home built in the Bakerville section of New Hartford. This view is a short jaunt north of the Litchfield Turnpike on North Road (now Cedar Lane). A high log fence encompassed the saltbox-style house in the early 1700s because people feared attacks by the New York Mohawk Indians. The last documented deadly attack by the Indians was in 1738, with no reports during the 100 years that the fortress stood. The fence was known to still be there in 1854. John Enright, an immigrant from Ireland, was a cobbler in his shop behind the Jones Blacksmith Shop. After his death, his family lived there until 1892. Axel Hallden, of Swedish descent and also a cobbler, acquired it, selling to John Hager, who sold to Floyd and Bertha Snyder in 1905. It was purchased by the Torrington Rod and Gun Club *c.* 1930 and then by George Weston and his wife. The next owner was William Leonard. (Courtesy Charles William Anderson.)

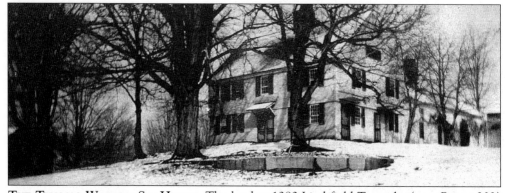

THE THOMAS WATSON SR. HOUSE. The land at 1380 Litchfield Turnpike (now Route 202) belonged to one of the first settlers, Levi Watson. He gave it to his son Thomas Watson, who built the main house *c.* 1787. In 1821, Thomas Watson moved, leaving the farmstead for his son Thomas Watson Jr. to run. By 1851, Thomas Watson Jr. owned 500 acres and won first prize for the best-cultivated farm. After he and his wife died, the part of the estate now called Ramstein farm was sold as one estate, and Ransley Hull bought the portion called Maple Avenue Farm, at 1380 Litchfield Turnpike. In the 1800s, Elisha A. Marsh, who was born in 1874, and his first wife, Hannah, daughter of Ransley Hull, bought the farm. Later Elisha A. Marsh married Amelia Bond. In 1941, the farm was sold to John P. and Edith Kinsey, and the main house was later acquired by their son Silas Kinsey. (Courtesy Bill Stafford.)

56

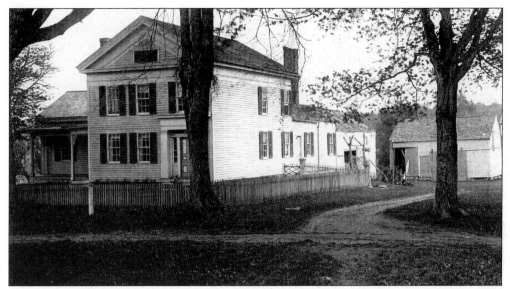

An 1840 Home. The house on 165 Gillette Road, just past Baherns Road, on the left, was built on an early settlement home-lot by William Watson in 1840. At the time of this photograph, before telephone or electrical wiring were installed, it was the residence of Charles McKee. The home was owned in the early 1900s by Plesent Valentine (1909–1988), a former president of the New Hartford Historical Society, and his wife Eva (Adams) Orie Valentine. In December 2001, the property was transferred to Lois and Anthony Orie, a son of Eva Valentine. (Courtesy Douglas E. Roberts.)

Edgar Clarke. Edgar A. Clarke was both the postmaster and a teacher in Bakerville. He had a medical problem with his legs so he engineered a two-wheeled device to enable himself to move around. In 1890, a picture of him was taken with his class at Bakerville School (see page 54). Clarke died in 1934. (Courtesy George Ganung.)

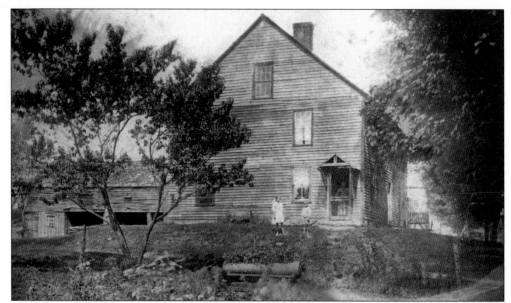

THE ISSAC WATSON HOUSE. This was one of the early farmsteads of Bakerville. It is referred to as the Isaac Watson House and is believed to have been built just after the John Cyprian Watson House was built in 1740. The home is located on 251 Cedar Lane at the corner of Niles Road. In 1862, when Isaac passed on, he left the estate to his son Edmund Watson. The Watsons defaulted on the mortgage, resulting in the state of Connecticut holding the residence until *c.* 1891. The state then sold it to private owners. (Courtesy Braxton Dew.)

THE ISSAC WATSON HOUSE, 1948. The Eisendraths owned the the Issac Watson House until they sold it in 1944. William "Braxton" Dew, a lawyer, and his wife, Letty, acquired the residence from the Eisendraths and kept the grounds neatly groomed. The Dews called it "Little Tuckahoe," named after the Virginia plantation "Tuckahoe," where Dew was raised. This is a rear view of the house in 1948. By that time, the carriage house in the rear (left) had been fashioned into a living room measuring 28 feet by 50 feet. In addition to its 13 rooms, the house has a screened sleeping porch on the second floor (right). The 11 stately maple trees lining the front yard are nearly gone now. (Courtesy Braxton Dew.)

WESLEY RAMSTEIN. As a small tyke, Wesley Ramstein poses near the withers of a workhorse harnessed to pull a wagon or other farm implement. He lived on the homestead known as Ramstein Farm. The farm, operated in more recent years by Darren Raymond (formerly of Canton), is situated on the hill at the intersection of Litchfield Turnpike (now Route 202) and Ramstein Road. The property was once part of the Thomas Watson estate, with the main house at 1380 Litchfield Turnpike now known as the Kinsey Farm. (Courtesy Bill Stafford.)

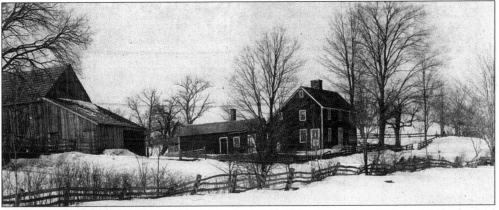

THE KATHLEEN BARNES HOUSE. Kathleen Barnes lived in this saltbox house, which is located on the farm on Bruning Road where. A 1923 graduate of Radcliffe College, she majored in Greek. She married Joseph Barnes, an editor, translator, and foreign correspondent for the Herald Tribune. In her early years, she sought a career in acting. Later, she wrote romance stories called "True Confessions." She was elected vice president of the New Hartford Historical Society in 1972 while Howell Hubert Richards was serving as president. She was well known as a civic activist. Her specialty was in environmental issues. She was a founder, along with the Eureka Grange in Nepaug, of New Hartford Day, the of which was in 1975 and included displays from the grange, the garden club, political entries, and several vendors. The festival still occurs on a Sunday in September each year. Kathleen Barnes lived to age 81 and died in August 1984, leaving her accomplishments to the history of the town of New Hartford. (Courtesy Douglas E. Roberts.)

THE CHILDREN OF GEORGE W. JONES. At the Jones Homestead, Ethel and Warren Jones, children of George W. Jones (1861–1955) and Jessie (Wheeler) Jones, play outside their brick house in the early 1900s. Note that the umbrella Ethel Jones (Bartholomew) holds and the one hanging on the porch clothesline are made the same as umbrellas are now. Warren Jones (1899–1963) wears bib overhauls that are back in style today. (Courtesy Barbara [Jones] Goff.)

THE BAKER-JONES HOMESTEAD. The home of Anthony Baker was built of red brick on the south side of the Litchfield Turnpike between the Cupola House and the Old Mill in 1829. George W. Jones and his wife bought it in 1893. They later added the porch and the ell in the back. The four chimneys and fireplaces were taken down in 1902 and replaced by one central chimney. At this house, the Jones children grew up: Edna Jones (Anderson), Warren Jones, and Ethel Jones (Bartholomew), who wrote *The History of Bakersville and Surrounding Areas* and self-published it in 1975. (Courtesy Charles William Anderson.)

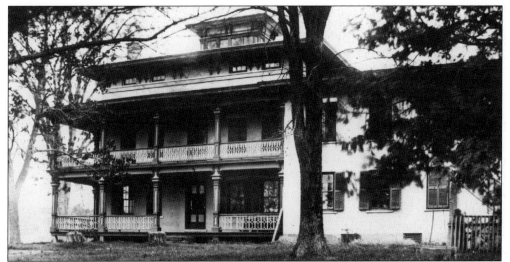

ROYAL WATSON'S HOUSE. Royal Watson built this large house on Winchester Road at the corner of Shadybrook Road after a profitable gold rush trip to California. He and a Mr. Henderson from Nepaug went together by schooner around South America between 1849 and 1852. They obviously returned with a profitable haul, but not of gold. The two men started a stagecoach route in California to supply prospectors in the mining fields with supplies. W.N. Jones owned the homestead in 1874. The brick house next door, with a carved date of 1822, belonged to Capt. Thomas Watson. (Courtesy George Ganung.)

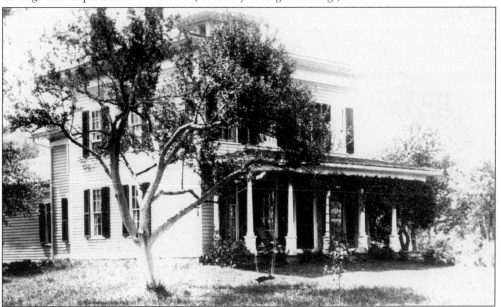

THE CUPOLA HOUSE. Located in the center of Bakerville is this Italianate-style residence known as the Cupola House. Anthony Baker built it for his son John Scott Baker, who married Martha Moore. The construction was begun in 1851 and was completed in 1855, just before Anthony Baker died. Behind the house is Cotton Hill. Frank Watson owned it in the early 1900s. In the late 1940s, it was owned by Gaston and Antonette DePermentier. As former restaurateurs, they used it to cater private parties. Ken and Carol Zwart lived there from 1977 to 1995, before making their home in Vermont. (Courtesy Charles William Anderson.)

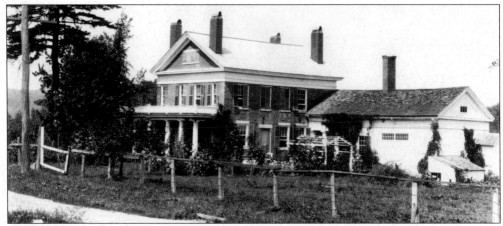

WALHALLA. This stately Greek Revival home known as Walhalla was built by Alonso Neal in the center of Bakerville in 1835–1836. New York financier Jeremiah Milbank, the financial backer of the inventor of condensed milk Gail Borden, who conducted his first experiments in Bakerville, purchased it as a weekend retreat in 1866. Milbank also financed Borden protégé Julius Pond of Torrington, who produced condensed milk in the Old Tannery building, just across the main road. Barrels of Pond's Condensed Milk were stored in Walhalla's carriage house ell before being canned in the old toyshop building to the rear. In 1900, Walhalla was purchased for $100 from local blacksmith George Jones by poet and lyricist Juan Woodruff Lewis, a retired Civil War colonel and his wife, pioneering feminist writer Theresa Lewis. Colonel Lewis died here in 1920. Among the subsequent owners were Alden Arthur and Emilie Benson Knipe, who coauthored adventure books for girls at Walhalla in the 1920s and 1930s. Alden Knipe was a direct descendant of Pilgrim John Alden. Emilie Knipe died in 1954. The home is currently owned and being restored by writer Neal Yates and his wife, Kathy Beyer-Yates. (Courtesy Neal Yates.)

THE BALLINGER HOME AND STUDIO. Harry R. Ballinger (1892–1993) was an artist who taught his skill and wrote a half-dozen books on how to paint, which are on loan in the Bakerville Library. He bought this home on the west corner of Litchfield Turnpike (now Route 202) and East Cotton Hill Road in 1936. In his apple orchard on the west side of the house, he built a studio with large north-facing front windows to provide the correct light for his artistry. The building incorporated his home and a third-floor apartment where his mother lived. He divorced his first wife and married Kay Moloson (1896–1980), a portrait painter, while in Bakerville. Ballinger and his wife summered at Cape Ann, Massachusetts, where he was well known. The couple traveled the world seeking beautiful scenes to paint. Ballinger sold the home to the Andrus family. (Courtesy Barbara [Jones] Goff.)

THE LEVI MARSH PLACE. This house still stands at the corner of Cedar Lane and Marsh Road, still a dirt town road, in Bakerville. The house has remained in the Marsh family for more than 200 years. Pictured are probably Levi B. Marsh, born in 1836, and his wife, Frances A. (Ellison) Marsh (1835–1911). A descendant Joseph Marsh is the present owner. (Courtesy Bill Stafford.)

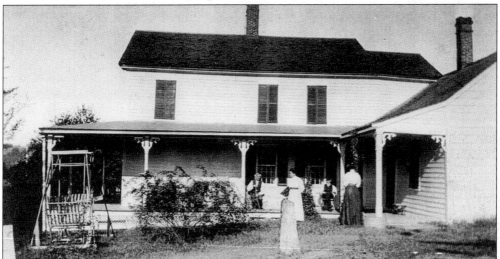

THE AARON GATES HOME. This house is located on the corner of North Road (now Cedar Lane) and Gillette Road across from the Leonard home (see page 56). In 1853, Warren N. Jones and Ann Tucker were married and bought the eight-acre farm from Aaron Gate's widow. This property is now referred to as the Colombie Home. Ann (Tucker) Jones wove rag rugs and carpets on her loom as a business in the small room over the kitchen. After her death in 1908, the Jones home was sold to Samuel Lewis and his wife from Morris. They added a porch on the front that extended around to the side. Samuel Lewis died as a widower in 1924. His grandson Gerrard Lewis bought the house and lived there with his family. He sold the five northern acres along North Road (now Cedar Lane) to the town of New Hartford. In 1941, the town built the Bakerville Consolidated School for grades one through eight on the land. Alphonse and Molly Columbie then bought the house, where they raised their three children. During their ownership, they removed the woodshed ell near the road. In 1964, a chicken house, built by George W. Jones when he owned the property, was moved across the road to the Leonard place. (Courtesy Barbara Goff.)

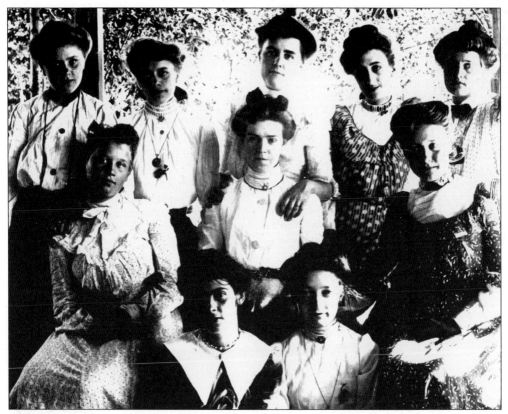

BAKERVILLE WOMEN. Here are 10 women from Bakerville who had their picture taken sometime between the end of the 1800s and the early 1900s. From left to right are the following: (front row) Nina Marsh and Carrie Hager; (second row) unidentified, Edie Goldbeck, and Augusta Fredsall Noonan; (back row) Mabel Clark, Hilda Lewis (1881–1952), Mrs. Harry Raymore, Lula Belden, and Andrette Hallden. (Courtesy Bakerville Library.)

A SUNDAY SCHOOL PICNIC. Pictured is Katherine R. Marsh, daughter of Elisha A. and Adelia (Bond) Marsh, enjoying a Sunday school picnic at the Marsh Pond. Her fashionable floor-length white cotton dress with push-up sleeves is topped off with a wide-brimmed, matching hat to help keep her cool. She became the bride of Richard Stafford and had a son Bill Stafford, who still resides on Route 202 in Bakerville. (Courtesy Bill Stafford.)

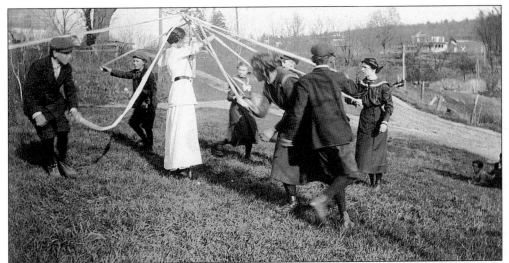

MAY DAY. A Bakerville teacher identified as Peggy is the focal point of the Maypole dancing. May 1 marks May Day, a dwindling celebration that originated in Germany. Youngsters traditionally celebrated the beginning of new life as the growth of the green trees and plants set the stage for the new harvest year for farmers. It was a custom to prepare May Day baskets, which were left at front doors as gifts. (Courtesy Bill Stafford.)

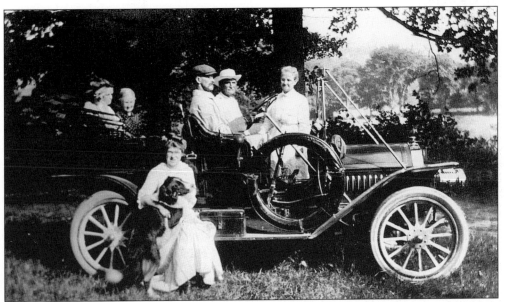

THE FIRST RIDE. Elisha A. and Adelia (Bond) Marsh take their first ride in a touring car, during the early 1900s. Their daughter, Katherine Marsh is sitting on the running board with the dog. It must have been an exciting day for the Marsh family and the owners of the car, Frank and Julia Kilburn. They chose a beautiful day to drive, but they are prepared for rain, since the folded canvas roof could be pulled over their heads and attached to the windshield in front. (Courtesy Bill Stafford.)

RELATED FAMILIES. Members of the Morse and Phillips families gather in Bakerville. From left to right are the following: (front row) Dorene J., Robert B., and Ralph C. Morse; (back row) young Richard W. Morse, Burtrum Morse (1908–1998), Beatrice (Hudson) Morse (born June 17, 1914), and nephew George Phillips and his wife, Jean (Jones) Phillips, daughter of Warren Jones (see page 60) and Virginia Jones. Beatrice (Hudson) Morse and Tiny (Hudson) Phillips (George Phillip's mother) were sisters. (Courtesy Ralph and Judy Morse.)

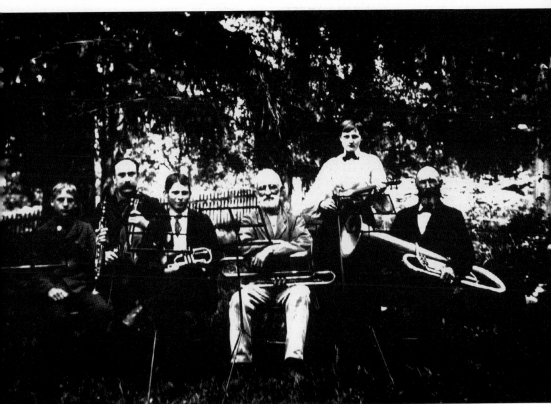

A BAKERVILLE BAND. Six members of this band in Bakerville had their picture taken sometime between the late 1800s and 1909. From left to right are Carl Halldene, Ed Clarke, Edward R. Gillette (1881–1972), Burton S. Osbourne (who died at age 79 in 1909), Audrette Halldene, and unidentified. (Courtesy Bakerville Library.)

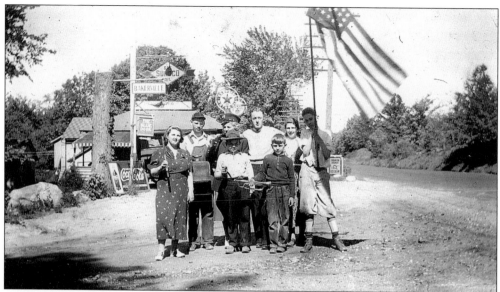

A BAKERVILLE PARADE. After the Bakerville Parade finished marching on May 30, 1938, this group posed just south of the gas station at the beginning of Maple Hollow Road. From left to right are Eunice Hudson, Allyn E. Sedgwick, Pearl Surdam, Frank Vickers, George French, Fred Vickers, Dorothy (Hudson) Stickney, and Malcolm "Bud" Sedgwick, who is holding the American flag. (Courtesy Ralph and Judy Morse.)

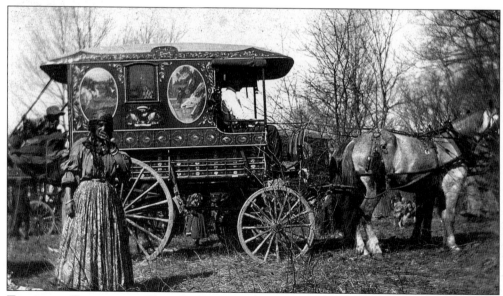

TRAVELING PERFORMERS. These Gypsies put on a surprise show for the Marsh family on Maple Avenue Farm in April 1911. In the days before television, roving groups would travel around to entertain people who could afford to barter and pay them. The performers would decorate their wagons with elaborate designs, and the women would dress up in their unique fashion by decorating themselves with flashy jewelry. (Courtesy Bill Stafford.)

Six

THE BEAUTY OF
WEST HILL
ADORNED WITH A LAKE

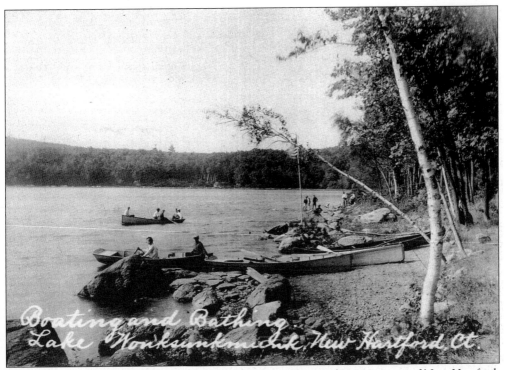

BOATING AND BATHING. West Hill Pond is a lake in the northwestern part of New Hartford. In 1852 and in 1874, it was recorded as being named Shepherds Pond. Later on, it was named Lake Wonksunkmunk and now, although it is a lake, it is named West Hill Pond. The town of New Hartford wanted to help prevent the lake from becoming surrounded by homes, so it purchased Brodie Park, which is now used by residents as a town beach. The rest of the shoreline is privately owned. (Courtesy Douglas E. Roberts.)

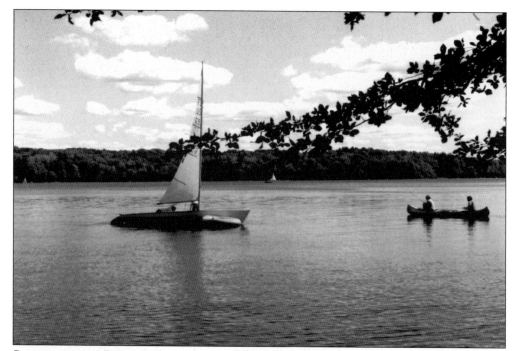

SAILING ON THE POND. Sailing is a peaceful sport on the lake on West Hill. The breeze picks up and the sails are full, as the *Lauryl Joy* ghosts away from its mooring. Across the water is Brodie Park, a private beach for New Hartford residents. (Courtesy Bonnie Flattery.)

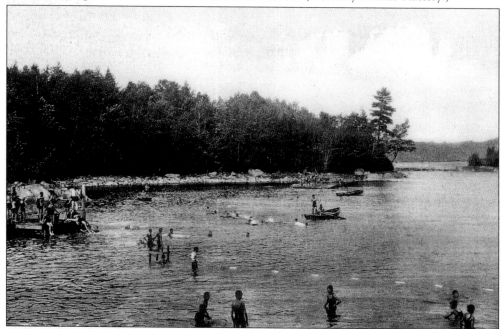

CAMP SEQUASSEN. Camp Sequassen is a Boy Scout camp on West Hill Pond. The shore at this camp is rocky. This snapshot was taken in the early 1900s, when the style for boys was just evolving to one-piece bathing trunks. Note the number of the boys' garments that are black, one-piece, over-the-shoulder, tank-top style. (Courtesy Douglas E. Roberts.)

70

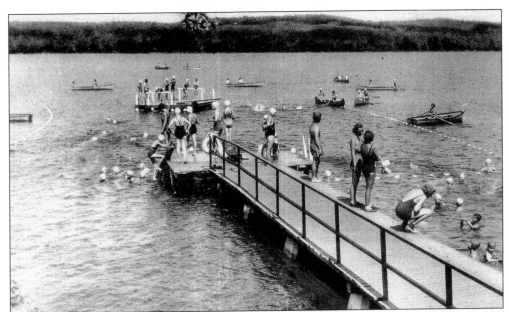

CAMP BERKSHIRE. On the southern side of West Hill Pond was Camp Berkshire for girls. This early 1900s scene captures the era when the fad was for women to wear bathing caps while swimming. The opposite shore appears to lack action. (Courtesy Douglas E. Roberts.)

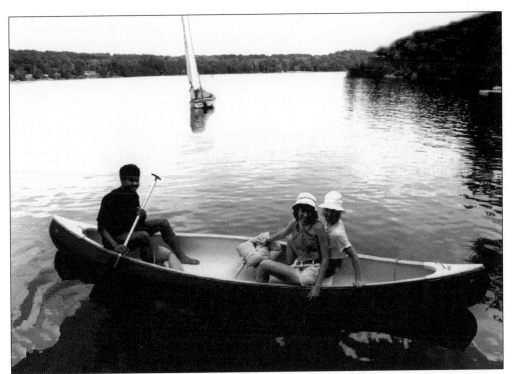

A FAVORITE PASTIME. Lake goers Brigid and Shonnon Flattery and Jonathan Sharp explore West Hill Pond in a canoe. The lake, which is named a pond, is a peaceful getaway where restrictions limit fast-paced boating. (Courtesy Bonnie Flattery.)

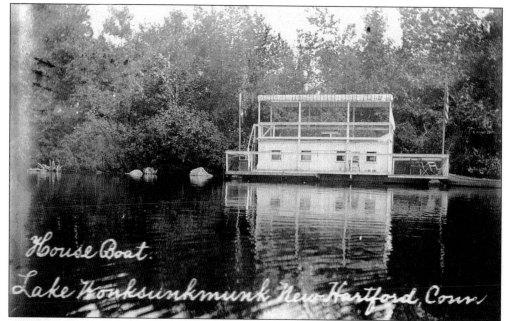

A Houseboat. This houseboat on West Hill Pond, then called Lake Wonksunkmunk, is ready for summer enjoyment. Equipped with a striped canvas roof on the top deck and a small boat attached to the back, it must have provided a spectacular view for its day. Chairs are on the rear sun deck, and a walking deck extends across the length of this side, giving the occupants access to the water. Note the patriotic flags on both ends. (Courtesy Douglas E. Roberts.)

The Water's Edge. This picture was taken during the one-penny postcard days. West Hill Pond was called Lake Wonksunkmunk at this time. The building in the foreground is literally on the water's edge, and its lakeside corners are on pillars that plunge into the depths of the water. The shore side of the structure has planks reaching the ground. Near the plank walk is a large wooden barrel. The young girl is wearing a long-sleeved print dress with a gathered skirt that flows just below her knees, appropriate dress for the early 1900s. (Courtesy Douglas E. Roberts.)

72

THE KISSING TREES. The serene environment is uninterrupted by this cottage, which has been a favorite vacation spot of the St. Pierre and Flattery families for many years. The two trees to the right of the path are affectionately know as the "kissing trees." (Courtesy Bonnie Flattery.)

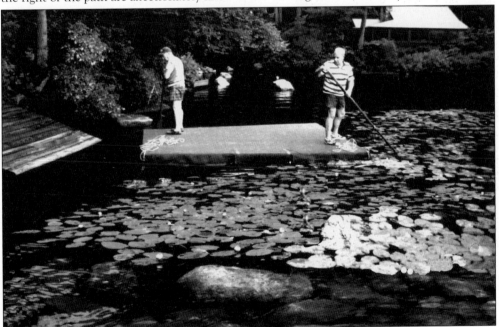

WEST HILL POND LILY PADS. Landowners on West Hill Pond enjoy the summer weather with little maintenance. Floating the raft is a yearly ritual of Joe St. Pierre and John Flattery, as they paddle through the water garden of lovely lily pads to bring the raft to the end of the dock. (Courtesy Bonnie Flattery.)

A VIEW OF WEST HILL. This picture of the west shore of West Hill Pond, then Lake Wonksunkmunk, was printed on a postcard. It shows a beautiful view of the lake undisturbed by activity. The correspondence side of the postcard has a cancellation stamp dated 1910. (Courtesy Douglas E. Roberts.)

THE JOHNSON COTTAGE. West Hill Pond is surrounded with camping enterprises, the New Hartford public beach known as Brodie Park, a store, and private seasonal and year-round homes. Here is a picturesque view of the Johnson family's cottage, peacefully tucked away in a cove on the west shore. (Courtesy Bonnie Flattery.)

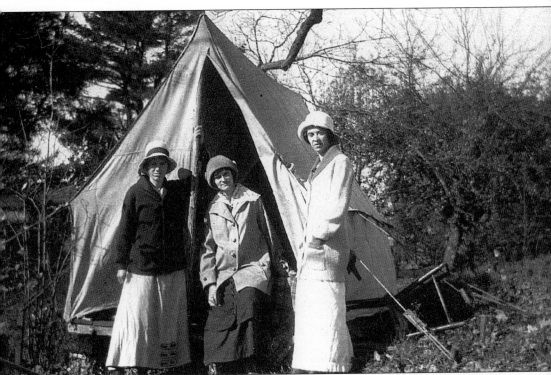

THE MARSH FAMILY CAMPING. The Marsh family of Maple Avenue Farm on Litchfield Turnpike (now Route 202) in Bakerville camped at West Hill for summer fun. This photograph was taken c. the start of the 20th century. From left to right are Katherine Marsh, Peggy (a family friend), and Nina Marsh. (Courtesy Bill Stafford.)

ON THE DOCK. Amy and Joseph St. Pierre and their son in-law, John Flattery, enjoy a Sunday afternoon on their dock near the water at West Hill Pond. (Courtesy Bonnie Flattery.)

Seven

NORTH VILLAGE
A NEW LOCATION FOR
THE CENTER OF TOWN

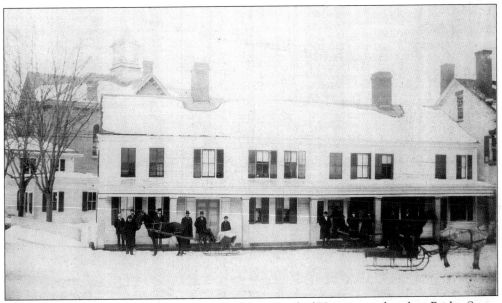

THE NEW HARTFORD HOUSE, C. 1871. The New Hartford House was a hotel on Bridge Street at the corner of Main Street (Route 44) in North Village (now New Hartford Center). On a cold winter day, F.A. Case is holding his horse Ned by the bridle. To the left is a house that was later replaced by a large two-story building, which extended to the hotel. When the new building facing Main Street was built to replace the house, it blocked the view of the clock tower on the building where the town hall is today. Therefore, it was removed and added to the new brick buildings and made to look like one structure. The building on the right of the New Hartford has also been rebuilt and is now occupied by Highland Hardware. (Courtesy Douglas E. Roberts.)

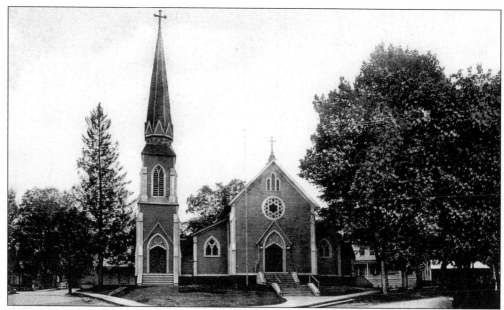

THE CHURCH OF THE IMMACULATE CONCEPTION. At the intersection of Route 44, Central Avenue, and Church Street in the center of New Hartford stands the Immaculate Conception Catholic Church. It is situated on a triangular piece of land facing the New Hartford House. The church, built during 1869–1870, is of Carpenter Gothic style, with hand hewn native chestnut timbers. The steeple on the front left is framed with 12-by-12 beams harboring iron reinforcement rods to make it structurally sound. (Courtesy Douglas E. Roberts.)

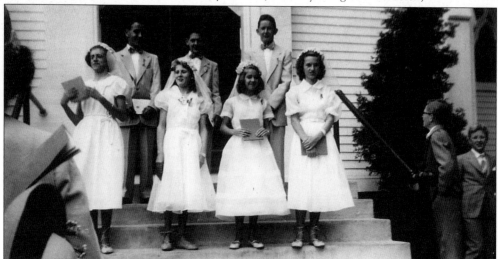

ST. MARY'S SCHOOL GRADUATION. St. Mary Parochial School, located between the Village Cemetery and St. Joseph's Convent on Route 219, held its eighth-grade graduations at the Immaculate Conception Catholic Church in the center of New Hartford. It was the custom for the girls to wear white street-length dresses and white veils crowning their heads. This class of 1951 is standing on the front steps of the church. From left to right are the following: (front row) Marjorie Osden, Mary Kelenis, Noel Loomis, and Terry Oswell; (back row) Armond Leterneau, Ed Kostak, and Richard Delaney, who died in an auto accident at age 21. (Courtesy Edward Kostak.)

ST. PAUL'S EVANGELICAL CHURCH. St. Paul's Evangelical Lutheran Church on Prospect Street in New Hartford was built in 1840. The church on the left and the parsonage on the right face east and are situated close to Holcomb Hill Road. The church belonged to the Baptists in Pleasant Valley who relocated to New Hartford. In 1870, the Baptists took the church building with them. They dismantled the structure giving each piece a code number. They used a team of oxen to pull the building material five miles down the frozen Farmington River. They rebuilt it at its present location on Prospect Street. (Courtesy Douglas E. Roberts.)

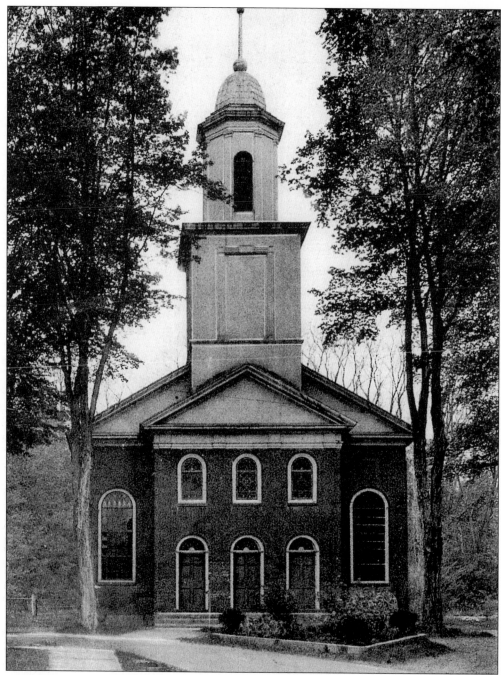

THE NORTH CONGREGATIONAL CHURCH. The North Congregational Church on Town Hill was the Congregational church of the town until November 1847, when the parishioners decided to hold services in Nepaug and North Village. They voted to sell "the church that stabbed itself" and branch out to the two new locations. In the north side of town, they erected this Congregational church at the end of Church Street in 1828. It is situated to face the short, straight road directly toward Main Street (Route 44). The church was built of red brick with a white towering steeple, white gables, and white board trim. (Courtesy Douglas E. Roberts.)

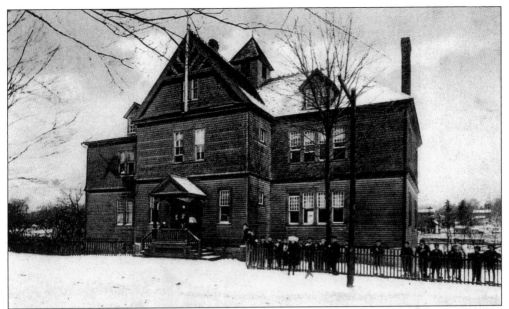

THE OLD HIGH SCHOOL. The old New Hartford High School building is located at 570 Main Street, north of the town center, on land running down to the Farmington River. The building was completed in 1886. The town of New Hartford sold the property in 1964, at which time it was renovated into apartments. Since 1959, sixth graders through seniors have attended Northwestern Regional School No. 7 in Barkhamsted. (Courtesy Douglas E. Roberts.)

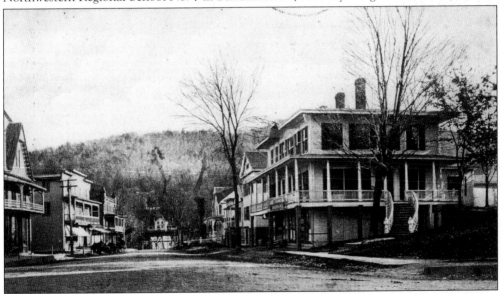

SOUTH MAIN STREET. The graceful curve of the stairs of the building on the right is a pleasing example of Victorian architecture. The building, which is on South Main Street, is currently owned by Anthony and Carol Fiore of New Hartford. The street level occupancy is now New Hartford Pizzeria, the Fiore's family-operated business. The upper floors are rental apartments. The building was moved back about 20 feet sometime after this picture was taken to allow room for the village green. The roadway was surfaced with concrete sections, and has since been resurfaced with black asphalt. (Courtesy Douglas E. Roberts.)

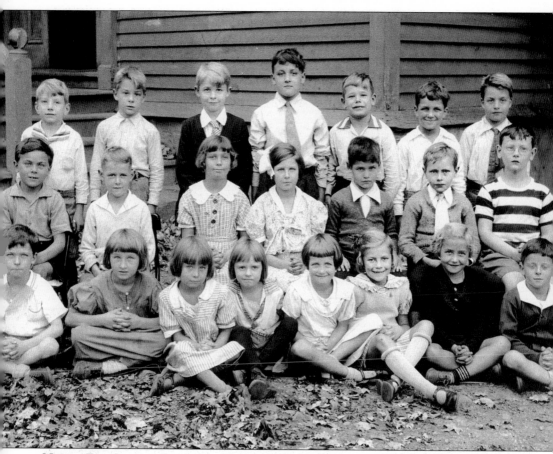

NORTH END SCHOOL STUDENTS. The North End School on Main Street in New Hartford had the first and second grades together. This class picture was taken in 1935. The teacher, Miss Simons, was not present. From left to right are the following: (front row) Wallace Matzko, Ruth Wabrek, Mary Yadack, Pauline Ellis, Mary Caine, Barbara Caine, Sally Case, and Edward Krompiegel; (middle row) Bobbie Wabrek, Edward Weber, Shirley Matzko, Ruth Burdick, Paul Burdick, Herbert Caine, and Harry Munroe Smith; (back row) Clinton Rude, unidentified, Benjamin Warner, unidentified, Bobby Stavinisky, George Henry, and ? Maxwell. (Courtesy Ben Warner.)

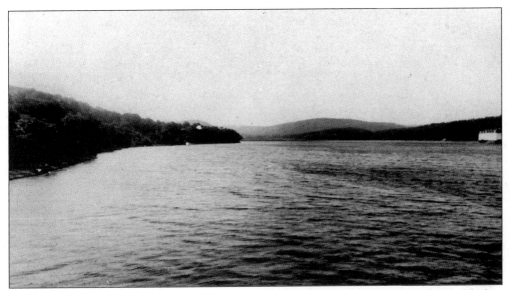

GREENWOODS POND. This view facing south shows the vast size of Greenwoods Pond before the flood of 1936 destroyed the dam. The dam was a power source for the Greenwoods Cotton Mill and the means for the railroad to cross. The white building in the upper right shows where the icehouse was located. The icehouse was used to store ice for local people and shipments going by train to New York City. (Courtesy Charles William Anderson.)

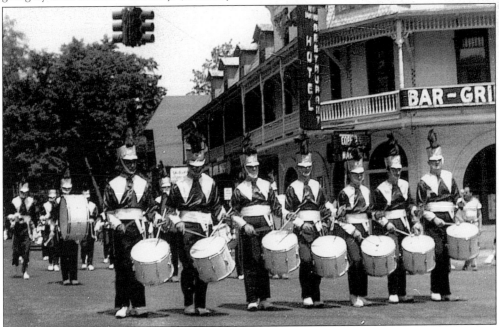

A NEW HARTFORD PARADE, 1957. The Memorial Day parade marched from the North End of New Hartford Center to Pine Meadow in July 1957. St. Mary's Band pauses on Route 44 in the center of town. The musicians are clad in their festive uniforms. The band is probably playing "The Bells of St. Mary," as it stands under the traffic light between the New Hartford House (right) and the Immaculate Conception Catholic Church (out of view on the left). (Author's collection.)

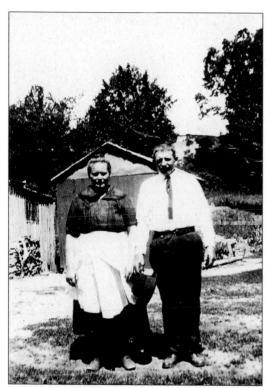

ANNIE AND JOHN KOSTAK. John Kostak Sr. and his wife, Annie (Salkis) Kostak, stand in their yard in New Hartford. John was born in Topartz, Czechoslovakia, on June 24, 1876. He immigrated from Dremen, Germany on the vessel named *North Germany Lloyd* on March 28, 1906, at age 30. He was naturalized on August 8, 1933, at age 56. His "Declaration of Intent" describes him as being 5 feet, 6 inches tall, 150 pounds, with brown hair and blue eyes. Annie was born in Lapsanka, Poland, in August 1881. She entered New York City in 1906 at age 25. She and John were married in February 1901 and had six children, two of whom were born in Topartz—Mary on October 19, 1901, and John, on June 5, 1903—and four of whom were born in New Hartford—Annie on April 24, 1909, Susie on October 16, 1913, Katie on March 24, 1916, and Helen on October 5, 1919. Katie Kostak now lives in her nephew Ed Kostak's house on Cottage Street. (Courtesy Ed Kostak.)

JOHN KOSTAK JR. Born in Austria in 1904, John Kostak Jr. immigrated to America with his parents at age one. He lived the remainder of his 55 years in New Hartford near the center of town. He was naturalized at age 26 on September 3, 1930. His Declaration of Intention describes him as being 5 feet, 7 inches tall and 140 pounds. He was a machinist and assembler in local factories. He married Mary K. Krutka of Cohoes, New York. The couple lived on Holcombe Hill and then bought a home on Prospect Street. They had three children: Bernice, Kenneth, and Edward. John Kostak (Courtesy Ed Kostak.)

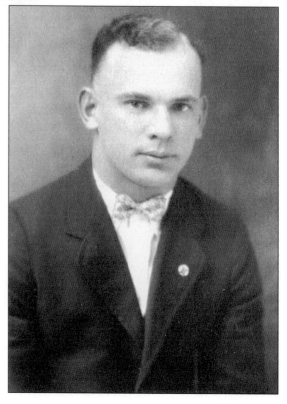

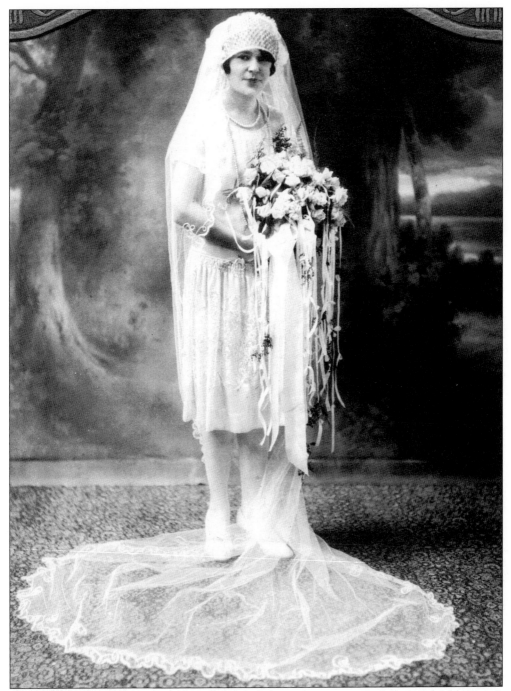

THE WEDDING DAY. At age 21, Mary K. Krutka of Cohoes, New York, married John Kostak Jr., age 24, of New Hartford. Father Ambrose Greelis performed the marriage on October 12, 1927, at the Immaculate Conception Catholic Church. Mary was dressed in white and carried a large bouquet of flowers with cascading white ribbons. The formal wedding dress had a street-length skirt draped with a delicate net veil that extended to the floor and spread neatly around her as she posed for pictures. (Courtesy Ed Kostak.)

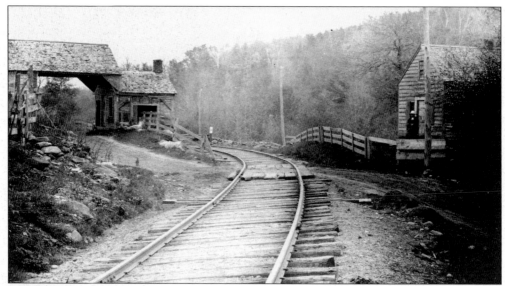

THE TOLLGATE. This tollgate on Greenwoods Turnpike north of North Village in Winsted was still standing after a railroad was built from Canton to Winsted. The old road crossed the track just before the approach to the tollhouse. The ground was rearranged to level the track, and the length of the fence was extended. The planks laid across the track allowed the carriages and cars to cross with less of a jolt. (Courtesy Charles William Anderson.)

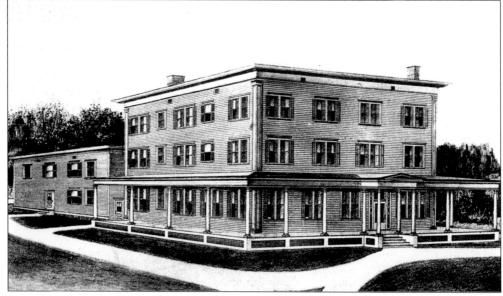

THE GREENWOODS INN. The Greenwoods Inn was named after the Greenwoods area. From the center of New Hartford going toward Winsted on Route 44, the inn was on the left side, the second building past Church Street. The top portion of the inn was removed, and the structure was transformed into a low single-family residence with landscaped lawns. (Courtesy Douglas E. Roberts.)

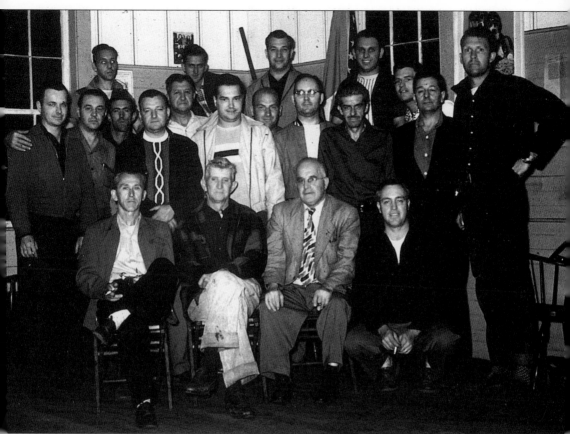

THE NEW HARTFORD FIRE DEPARTMENT. In 1954, there were 25 members in the New Hartford Fire Department. This old firehouse, which was washed out in the 1955 flood, was located on the Farmington River side of Holcomb Hill Road, across from the train depot. From left to right are the following: (front row) Andrew Matzko, Charles Warner (fire chief), Al Kennedy, and unidentified; (middle row) Ed McManus, John Marek, Chippey Chipman, John Skarupa, Andrew Rusinko, Bob Barry, Walter Wabrek, Nelson White, Bill Blanchette, John McCarthy, and John Hoffman; (back row) William Lowry, Regie Matzko, Carl Wabrek, Joe Monyak, and Ben Warner. (Courtesy Ben Warner.)

THE NEW HARTFORD FIRE DEPARTMENT. In the early 1900s, many towns sponsored their own baseball team. The teams would play against teams from neighboring towns. Pictured here in 1923 are the members of the New Hartford Baseball Club. From left to right are the following: (front row) unidentified (catcher), John Kostak Jr., Brick Laundry (batboy), Beaser Cain, and Jimmy Parrott; (back row) unidentified, E. Thiery, Mickey Dudak, Elmer Healy, Otto Jahne, and Charlie Warner. (Courtesy Ben Warner.)

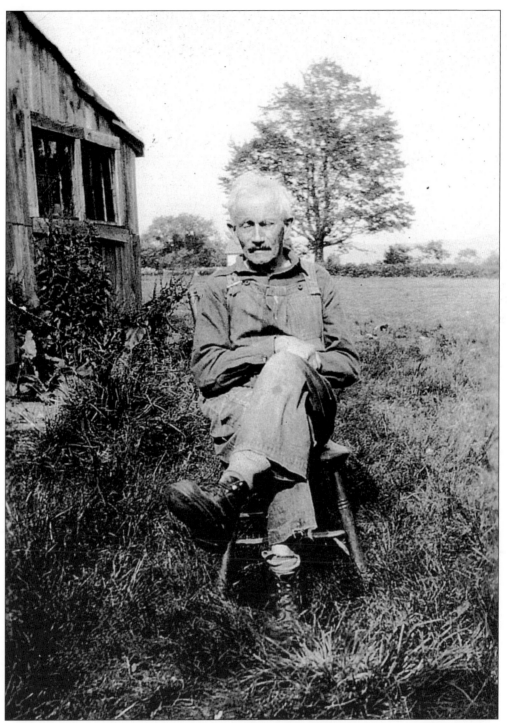

ALBERT SIMONS. Albert L. Simons of New Hartford, age 78, relaxes outside one day. Born on March 29, 1858, he died on November 18, 1936. His house, which no longer stands, was on Stub Hollow Road, the second one one the right from West Hill Road. (Courtesy Ed Barden.)

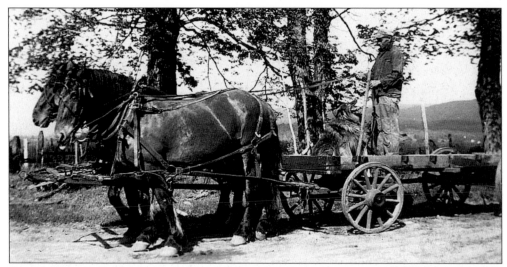

CHARLES BARDEN. Charles H. Barden, born *c.* 1900, drives his team of workhorses on his farm at the top of Burgoyne Heights in New Hartford. The farm is situated at the top of the mountain, which slopes down on each side. The road was named because Gen. Burgoyne of the German army during World War I marched through Johnny Cake Lane and camped out in the area with his unit. The view is magnificent behind the wagon, looking over to Ski Sundown near Lake McDonough (formally Compensating Reservoir). (Courtesy Ed Barden.)

BARDEN'S ORIGINAL BARN. Charles H. Barden moved from his farm at Cample Falls in Norfolk. He and his dog herded his six cows from Norfolk to the new farm on Burgoyne Heights in New Hartford. After 16 years of building up the dairy farm, the old barn (right) burned in November 1943. Barden nearly died trying to save his livestock. Blinded by smoke, he felt his way through the barn. He was pinned down by a rampant heifer and used the last bit of strength to recognize the doorsill and pull himself out. He laid face down on the ground unconscious until rescued. The burning barn door immediately collapsed on the spot where he had lain. A donation drive collected funds from as far as Coventry, Hartford, New Britain, Cheshire, and Waterbury. The Metropolitan District Commission donated materials including the wooden pegs from Grace Barnes's place on Brown's Corner in Nepaug. Barn-raising volunteers dismantled the barn in Nepaug and used the large timbers for framing a new barn for Barden on Burgoyne Heights. (Courtesy Ed Barden.)

MAREKS' GENERAL STORE. Mareks' General Store was located at 11 Cottage Street in the early 1900s. The building is on the south side of the street and is now the second home in from the bridge over the Farmington River. Standing in front of the store are Mr. and Mrs. Marek, the storeowners, in the early 1900s. John Kostak Sr., who was born on June 24, 1876, and his wife, Annie, lived on the right side of the building, caring for their grandchildren: Bernice, Kenneth, and Edward Kostak. Their mother Mary (Krutka) Kostak was in a tuberculosis hospital. The youngest child Ed now owns the residence and lives on the left side, and John Kostak Sr.'s daughter Katie lives on the right. (Courtesy Steven Marek.)

THE NEW HARTFORD TOWN FIRE. In 1856, a destructive fire destroyed buildings in North Village (now the center of New Hartford). This image was taken during the fire, showing little remains due to the limited visibility of the smoke. Rebuilding of the structures changed the identity of the village. (Courtesy Douglas E. Roberts.)

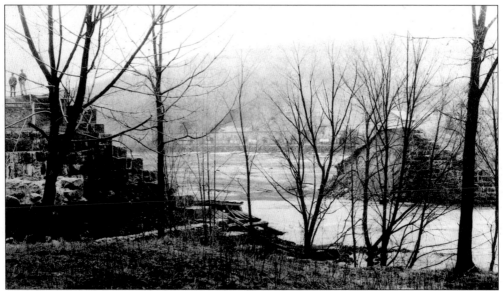

THE GREENWOODS DAM. On March 18, 1936, a devastating flood toppled property and marred the Farmington River banks along the waters. New Hartford once was one of the largest mill towns in western Connecticut. The flood destroyed the Greenwoods Dam—a power source of the Greenwoods cotton mill—that was built across the Farmington River, leaving only these disturbed abutments. (Courtesy Janet W. [Hall] Lavoie.)

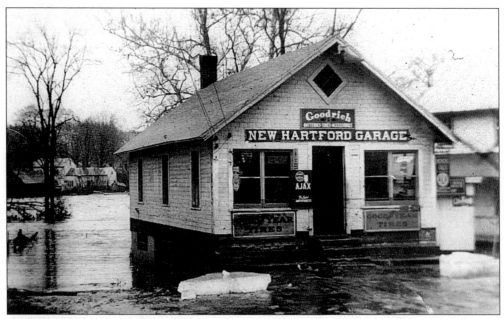

THE NEW HARTFORD GARAGE. The flood on March 18, 1936, roared up a storm with the New Hartford Garage along with other buildings on the banks of the Farmington River. The garage faced Route 44 and was located between on the south side of the building now occupied by Charleen Kennedy's hair salon called the Scissors. The flood damaged the three sections of New Hartford: North Village (now the center of town), Pine Meadow, and Satan's Kingdom. (Courtesy Janet W. [Hall] Lavoie.)

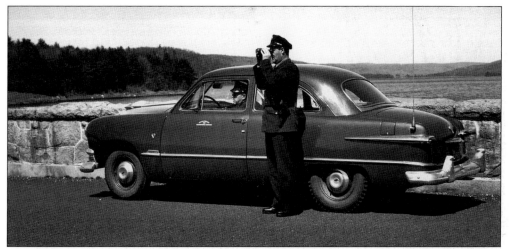

THE COMPENSATING RESERVOIR. The Compensating Reservoir (now Lake McDonough) is a recreational body of water tucked away in the northeast corner of New Hartford. The reservoir has been used for recreational purposes such as boating, canoeing, fishing, and swimming. It is owned by the Metropolitan District Commission and was built to compensate for the dry season. The reservoir stored up water to be released when the Farmington River was too low to keep the mills running. The commission purchased hundreds of acres of land in the surrounding towns to provide a watershed. It has its own special police officers to patrol their property and enforce the pollution laws. This picture was taken in the early 1950s on Route 318 over the Saville Dam separating the Compensating Reservoirs from the Barkhamsted Reservoir. Standing is Arnold L. Vienot of New Hartford, sergeant of the special police force, observing an incident near the spillway. Earl "Cookie" Cook is the driver working in the two-man team. (Author's collection.)

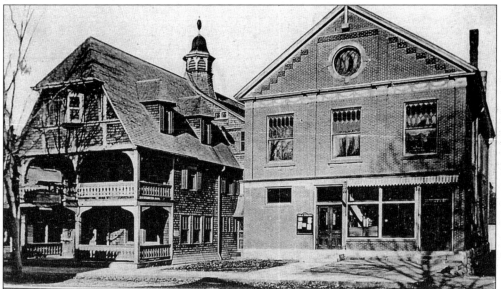

THE OLD POST OFFICE. The old New Hartford Post Office (right) was on Main Street, and going toward Winstead, was the first building after the New Hartford House and adjoining entity. The post office has since become the town hall. The building on the left was torn down recently to remodel and extend the town hall. (Courtesy Clair W. Wilder.)

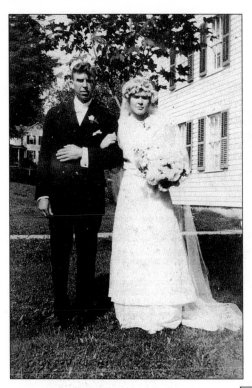

THE WARNERS. Winfield A. Warner, son of Albert A. and Amelia (Case) Warner, married Lottie Burdick on August 31, 1915, at the bride's home on Holcomb Hill Road. The groom was born on October 6, 1878, and passed away in 1943. The bride was born on April 27, 1894, and passed away in 1962. The couple had two children: Benjamin and Charlotte Warner (Boratko). (Courtesy Ben Warner.)

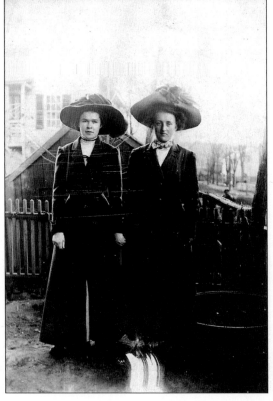

FRIENDS ON PROSPECT STREET. Lottie Burdick, born April 27, 1894, poses on Prospect Street in New Hartford with a friend, Anna Wabrek, when they were both 18 years old. Lottie grew up in town and had two brothers, Asa and Erving, and a sister, Maud. Lottie later married Winfield A. Warner of New Hartford. (Courtesy Ben Warner.)

ALBERT WARNER AND HIS SON.
Albert A. Warner (1838–1899) is holding his youngest son, Charles A. Warner (1895–1967). Albert was born on West Hill; he was the son of Benjamin and Catherine Warner. He and his wife, Amelia (Case) Warner, had three boys, Ira, Winfield, and Charles, and a daughter that died at birth. Warner was a farmer who lived on the East Branch of the Farmington River in an area called South Hollow District near the Barkhamsted Reservoir. His son Charles grew up there and then moved to the Pike Place on Prospect Street when the Metropolitan District Commission bought the South Hollow Farm to build the Compensating Reservoir (now Lake McDonough). (Courtesy Ben Warner.)

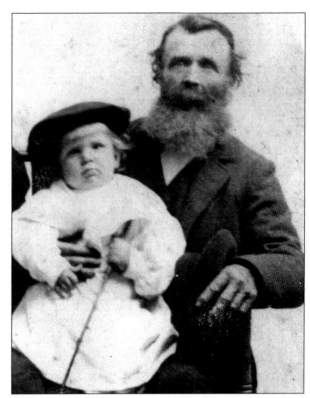

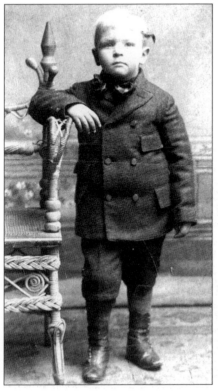

CHARLES WARNER. Charles A. Warner was born in 1895 and lived in the South Hollow District, which is now under the south end of Lake McDonough (previously Compensating Reservoir). He was the son of Albert A. and Amelia (Case) Warner, and brother of Winfield (Ben Warner's father) and Ira Warner. Charles Warner never married but was known to be a great ballroom dancer. (Courtesy Ben Warner.)

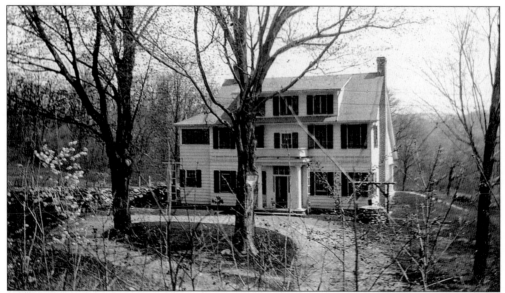

THE HALL HOUSE, OLD WELL. After her husband Harrison R. Hall Sr. died on December 11, 1911, in Pennsylvania, Clemintina Janes (Barber) Hall, who was born on March 3, 1879, in Kent, Ohio, stayed with her cousin Hallie Parsons. Hallie Parsons, born in 1871, lived at Hillcrest, which was built in 1845 on Route 219 or Town Hill Road. The Barber and Parsons families had solid roots in Connecticut. Satisfied with New Hartford, Clemintina rented the Goodwin house on West Hill Road until she could build her own estate in 1917 at 6 Johnny Cake Lane. She named her home Old Well because of the stone wells on the property. The immense five-bedroom house was originally planned to accommodate one of her brothers. Instead, her son Harrison R. Hall Jr., his wife, Helen, and their three children, Edward and the twins Janet and Robert lived there until 1951. (Courtesy Janet W. [Hall] Lavoie.)

CLEMINTINA JANES BARBER. Clemintina Janes Barber (Hall), owner and builder of Old Well, is on her tricycle as a young girl living in Ohio. Born on March 3, 1879, she graduated from the University of Buchtel College in Akron, Ohio. She moved to Pennsylvania and then to New Hartford, where she resided for 32 years, beginning in 1926. (Courtesy Janet W. [Hall] Lavoie.)

THE HALL FAMILY. Clemintina Janes (Barber) Hall (left) married Harrison R. Hall Sr. on October 17, 1900. Harrison Hall Sr. was a prominent iron manufacturer and builder of blast furnaces. He also was a member of the American Institute of Mining Engineers. For six years, he was superintendent of Crane Iron Works of the Empire Steel and Iron Company in Catasauqua, Pennsylvania. He died December 11, 1911, following a serious operation. Pictured with their mother are, from left to right, Caroline Osborne Hall (Todd), Helen Warren Hall (Monier), and Harrison Hall Jr. The two younger children attended a boarding school named Montjoie in a village in Lausanne, Switzerland, while the mother stayed in France. The eldest child, Helen, owned and resided in their house in Lille, France, while owning another home in Paris, France, where her husband, Raymond, was a professor of law. Clemintina remained owner of Old Well in New Hartford while she and her children were in Europe and then returned to Connecticut where the younger children continued their education. (Courtesy Janet W. [Hall] Lavoie.)

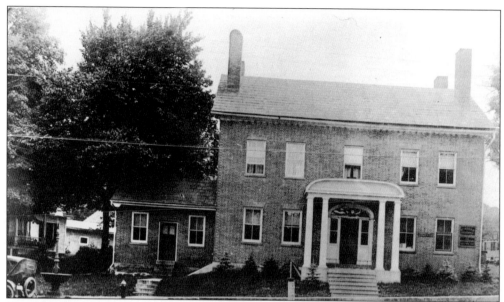

THE NEW HARTFORD LIBRARY. The New Hartford Public Library was founded in 1909. The old brick building is in the center of town at the intersection of Main Street, Church Street, and Central Avenue. A new library was opened in 2001 on Central Avenue between the center and Route 219. The new building, as of December 2001, has been renamed the Licia and Mason Beekley Community Library. (Courtesy George Ganung.)

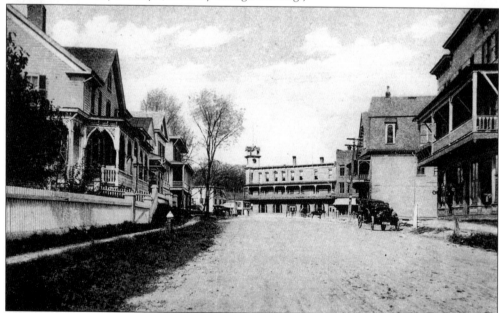

MAIN STREET, NEW HARTFORD. Facing north on Main Street in New Hartford center, the New Hartford Hotel is straight ahead. Since this photograph was taken, the buildings have been moved to the left to expand and provide space for a center green. Elias Howe invented the sewing machine in the basement of the former New Hartford House before it was destroyed by fire. The two buildings behind the car no longer exist. A new building for the New Hartford Trust Company and its parking lot has replaced it. (Courtesy Clair W. Wilder.)

Eight
PINE MEADOW

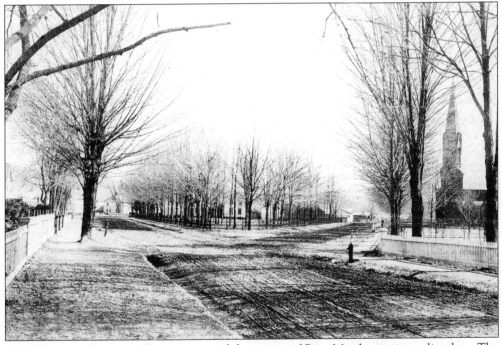

PINE MEADOW CENTER. This is a view of the center of Pine Meadow in its earlier days. The village green in the center of the picture is Chapin Park, named after the Chapin-Stephens Company. There was a Chapin house directly on the other side of the church. Note the fence surrounding the green. This view is facing south on Main Street, now part of Route 44. The turn that runs in front of St. John's Episcopal Church (right) is Church Street. (Courtesy Douglas E. Roberts.)

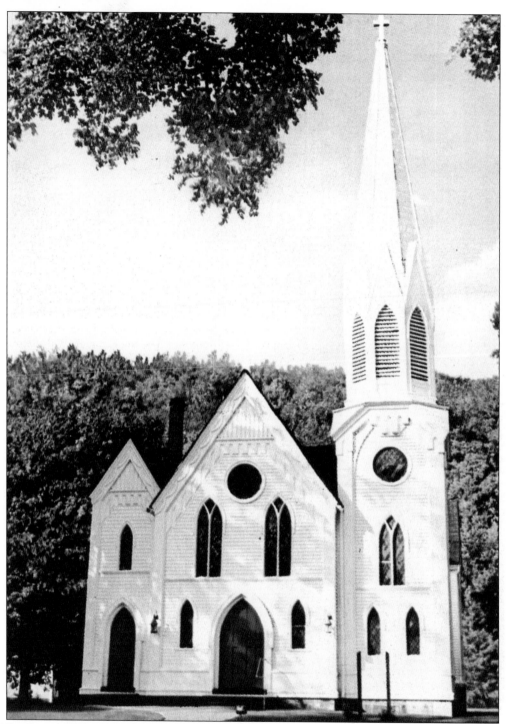

ST. JOHN'S EPISCOPAL CHURCH. St. John's Episcopal Church is located on Church Street at the corner of Main Street in Pine Meadow. This picture was taken with the photographer's back to the green. To the left, out of view, is the house that once was the Chapin residence of the Chapin-Stephens Company, a rule shop in Pine Meadow. (Courtesy Douglas E. Roberts.)

THE PINE MEADOW TRAIN STATION. The New York, New Haven & Hartford railroad station in Pine Meadow was along the Albany Turnpike (now Route 44). The tracks ran along the west side of the Farmington River from Satan's Kingdom to New Hartford Center. It was in service from the 1800s until it was disbanded in 1927 because road transportation provided less expensive and more convenient service. (Courtesy George Ganung.)

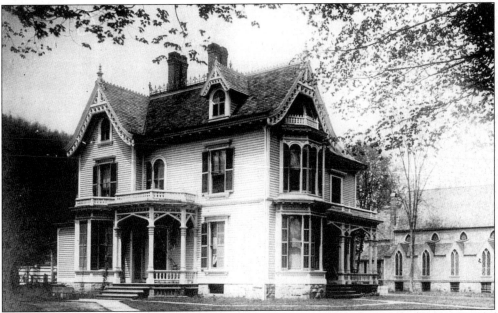

THE CHAPIN RESIDENCE. This stately Victorian house was the home of the Chapin family, owners of the Chapin-Stephens Company, nearby on Black Bridge Road. The house is situated next to St. John's Episcopal Church (right) in Pine Meadow. Both buildings face the village green, now called Chapin Park. At the time this picture was taken, the residence was owned by E.M. Chapin's wife. (Courtesy Douglas E. Roberts.)

DARIUS SMITH. Darius B. Smith came to New Hartford from Stockbridge, Massachusetts, at age 25. In 1840, he began his career working as a blacksmith for his brother John C. Smith and his partner, Sanford Brown. The two businessmen owned the New Hartford Joint Stock Company in Pine Meadow. Four years later, Darius Smith married Eliza Brown. He made his way up to the top in Pine Meadow and became co-owner of the D.B. Smith and Son factory. (Courtesy Douglas E. Roberts.)

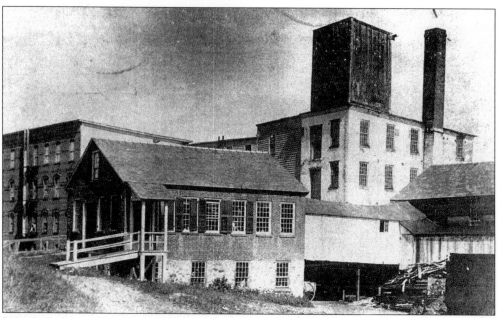

THE D.B. SMITH AND SON COMPANY. D.B. Smith and Son, previously owned by Smith and Brown, was one of the old factories in Pine Meadow. Darius B. Smith came from Stockbridge, Massachusetts, worked as a blacksmith for his brother, and eventually earned his own office (foreground) at the factory. With his son he became a co-owner of the business, which included a brass foundry, and iron foundry, a sawmill, a cotton mill, and this gristmill. The company closed in 1927. (Courtesy Douglas E. Roberts.)

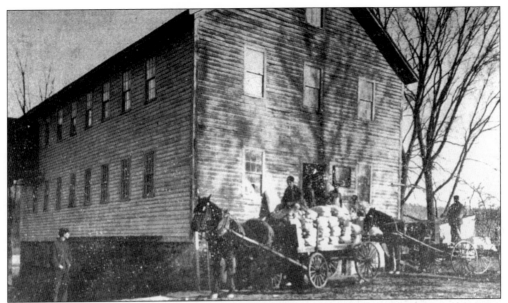

THE PINE MEADOW FACTORY. The D.B. Smith and Son factory in Pine Meadow included this cotton mill, which made duck cloth, reaper cloth, cider cloth, tubing, belting, and dryer felts for paper products. The grain was ground on the second floor by two grinding stones, eight inches thick and four feet in diameter. The upper grinding wheel was contoured into groves to turn against the stationary stone below, creating ground grain or cracked grain products. Seated on grain bags on the wagon is John Castanguay. In the doorway on the left stands Joseph Root. Root was the millwright who maintained the belts and wheels of the mill until *c.* 1910. In the doorway on the right is Frederick Brown. The driver on the wagon, in the back, and the boy on the back of the load are unidentified. Standing on the far left is John, nicknamed "What's on the Clock?" because he was always asking the time. (Courtesy Douglas E. Roberts.)

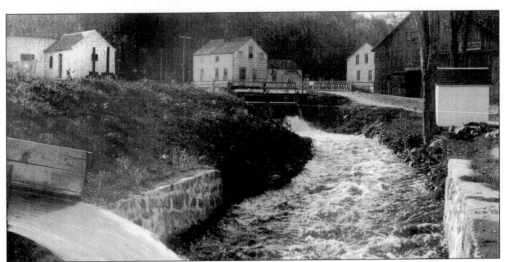

THE CANAL. The canal was a manmade waterway directing water for use as a power source for both the Chapin-Stephens Company and D.B. Smith and Son. This canal can still be found vacant between Main and Wickett Streets in Pine Meadow. Note the water pouring forcibly into the canal in the lower left corner. (Courtesy Douglas E. Roberts.)

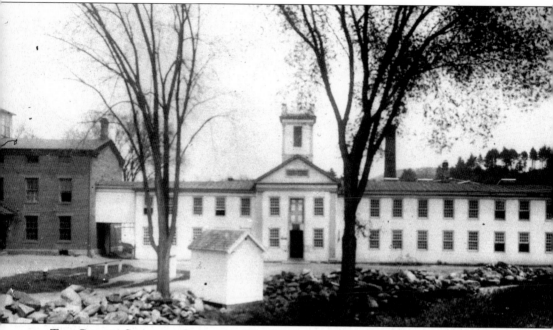

THE CHAPIN-STEPHENS COMPANY. The Chapin-Stephens Company manufactured hardware goods, including levels, rulers, and planes, during the industrial age in New Hartford. The formation of mills and small factories changed the North End of town from an agricultural to an industrial district. The Farmington River, being larger than the Nepaug River, encouraged mill owners to take advantage of the greater power source of the river in the north. With the influx of people, the center of town switched from Nepaug to North Village. The location of Chapin-Stephens Company on Black Bridge Road helped encourage the growth of the village of Pine Meadow, along the Farmington River. After the Chapin-Stephens Company dissolved in 1929, Stanley Works of New Britain bought the line of rulers to continue production. (Courtesy Charles William Anderson.)

THE BLACK BRIDGE. This covered bridge crossed the East Branch of the Farmington River in Pine Meadow. The bridge was located on Black Bridge Road near the Route 219 intersection. The wooden bridge was built in 1873 and was used until it washed out in the flood on March 18, 1936. It was 172 feet long. Covered bridges were common during this period because they sheltered the roadway from snow during the winter, making it passable. (Courtesy Charles William Anderson.)

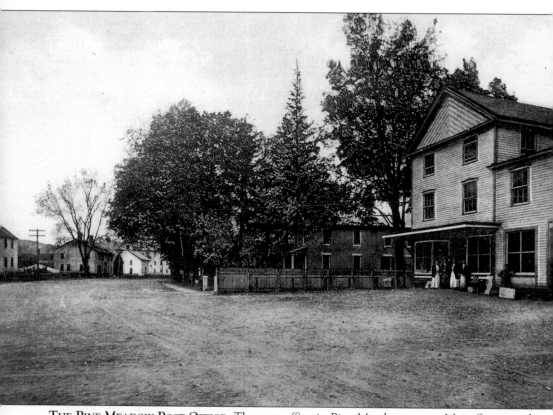

THE PINE MEADOW POST OFFICE. The post office in Pine Meadow was on Main Street at the intersection of Black Bridge Road. The building is on the right, with people gathered outside near the front door. The building next to it, which is partially obstructed by trees, is Greystone. Greystone is the stone house that the New Hartford Historical Society bought and successfully set up as its headquarters. In this photograph, Main Street is heading toward Canton. (Courtesy Douglas E. Roberts.)

Nine
Satan's Kingdom

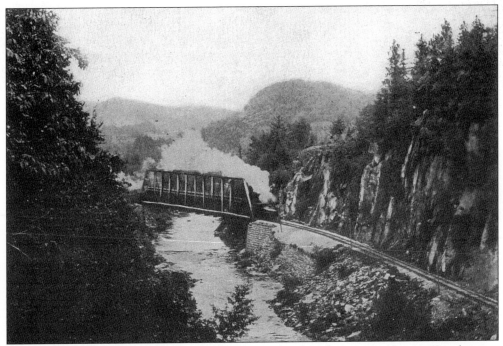

At the Bend in the Gorge. Headed around the bend in the gorge in Satan's Kingdom is a steam-driven locomotive crossing the Farmington River. It is heading north toward New Hartford Center. Thomas Savery of England patented the first practical steam engine in 1698. The steady stream of smoke that flows out of the engine's smokestack and rises in billowing swirls above the moving train must have been an exciting sight for country people. The sharp whistle could be heard from miles away with a continuous background sound of the clickity-clack from the rushing wheels. An experienced man could rest his ear upon a track to judge the distance of a train. (Courtesy Charles William Anderson.)

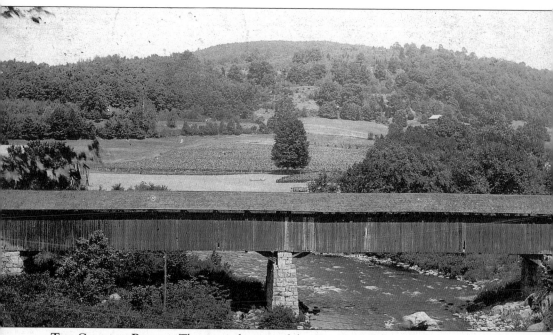

THE COVERED BRIDGE. This is a side view of the Satan's Kingdom Bridge, built in 1856. The vast expanse of the wooden bridge is 222 feet in length. The center support column shows skillful stonework. Satan's Kingdom acquired its name from the renegade Indians who lived in the area and were said to have robbed the trains passing through. (Courtesy Charles William Anderson.)

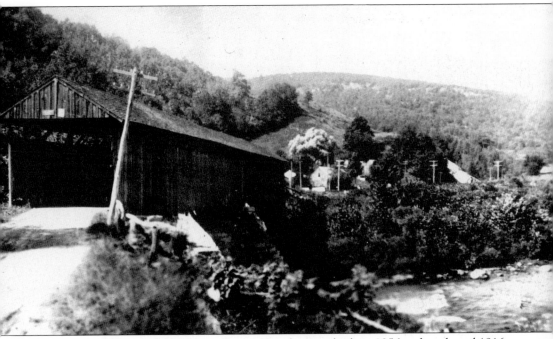

THE ENTRANCE. The covered bridge in Satan's Kingdom was built in 1856 and used until 1916 when it was replaced with an iron bridge. The covered bridge helped to keep snow from piling up in the roadway so the oxen- and horse-drawn wagons and motor vehicles could cross the Farmington River. The bridge abutments were made of hand-laid stones. The roofing was made of wood shingles. The floor joists consisted of large beam timbers, which carried the weight. In the right front corner is a rail fence which was used for property lines and animal fencing. Note the buildings north of the bridge on the way to New Hartford Center, most of which were washed downriver during the 1955 flood. (Courtesy Charles William Anderson.)

LOOKING UPSTREAM. From the gorge, the view upstream along the Farmington River in Satan's Kingdom reveals the railroad trestle (foreground). The covered bridge (background) is on the Albany Turnpike (now Route 44). The two roads head to the left toward the center of New Hartford. This picture was taken before the 1936 flood. Now, the water can be found dotted with both yellow and green tubes owned by the Farmington River Tubing business, which rents floating devices to the public for use as a cool refreshing summer sport. (Courtesy Douglas E. Roberts.)

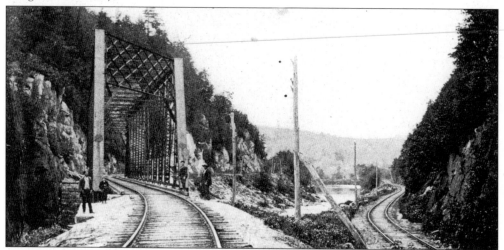

THE RAILROAD TRACKS. This picture was taken in the gorge of Satan's Kingdom. From left to right are Fred Morandus (1864–1941), Charles Mason, Rubin Mason, and Joe Mason. The track pictured on the right was referred to as the "North Track." It came into town from Collinsville, crossed in Collinsville and ran along the Farmington River through the gorge in Satan's Kingdom and on to New Hartford Center. The track pictured on the left over the iron bridge was called the "South Track." It came from Collinsville and then followed the east side of the Farmington River through the gorge in Satan's Kingdom and on northward. (Courtesy Charles William Anderson.)

Ten

LIVING OFF THE LAND

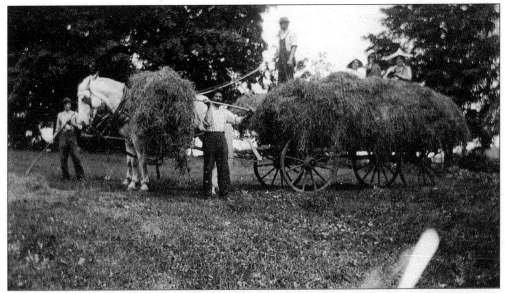

HAYING. In the early days, the self-supporting farmers used ingenuity and hard labor to provide for their families. Fully grown grass in the specially planted fields was cut by using a one-man scythe. In later years, horse-drawn mowing machines replaced the manual labor. A person would sit on a precariously perched seat, having no handles or sides to support him, to run the machine and simultaneously drive the horse. The hay would be turned in the field until it was dry. It was then raked. The windrows of raked hay would be picked up by a three-tined pitchfork and manually thrown on a wagon hitched to one or more horses. The person on the top of the wagonload of hay would stomp the loose hay, compacting it to prevent it from falling along the wayside. When the load was piled twice the height of what is pictured, the horses would pull the wagonload to the barns, where it was pitched into the haymow portion of the barn. Livestock would feed on daily portions of the hay throughout the winter. (Courtesy Bill Stafford.)

HARVESTING GRAIN. In autumn, the stalks holding grain seeds were cut, clumped into bunches, and left upright to dry in the field. The grain the Marsh family was harvesting here appears to be wheat. (Courtesy Bill Stafford.)

CORNSTALKS. Once the ears of corn were picked and stored in vented corncribs to use as animal feed during the winter, the cornstalks were left propped up in the field to dry. When the corn plants are cut while they are still green, they can be chopped with the ears of corn attached and put into silos to produce silage. Some farmers chose to let the animals loose in a cornfield to eat the green cornstalks, which is called hogging off. The hogging off will fatten the animals before butchering. (Courtesy Bill Stafford.)

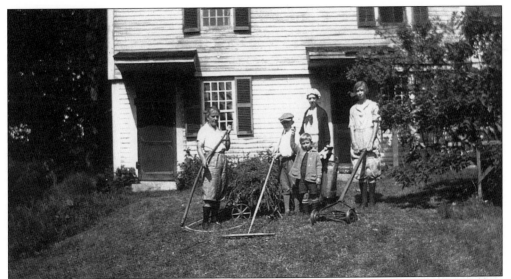

LAWN MAINTENANCE. Lawn care in the early 1900s was uncommon. Many families staked their grass-eating animals around the houses to keep the grass from growing too tall. The Marsh family on the Maple Avenue Farm of Bakerville is sharing the work of beautifying their home. Although three of the people are unidentified, the person behind the boy with his hand up is Adelia (Bond) Marsh, at the handles of the wooden wheel barrel, and on the right is Katherine Marsh (Stafford), behind the push lawn mower. (Courtesy Bill Stafford.)

HUSKING CORN. Ears of Indian corn freshly picked on Maple Avenue Farm, owned by Elisha A. and Adelia (Bond) Marsh, surround Katherine Marsh (Stafford). Her woven basket is full of colorful mature corn on the cob. Evidently, she has husked hundreds of ears and has a long day ahead of her. (Courtesy Bill Stafford.)

STUMP STUDY. The U.S. Forest Service took this picture in 1954 of Ben Warner (left) of New Hartford and Forester Everett Pearson studying the annual growth rings of a tree stump. The forester stopped periodically at Warner's farm, called the Pike Place, on Prospect Street to educate Warner on the use of his sawmill. Pictures were used for the purpose of publicity aimed at encouraging other people to start sawmills on their farms. (Courtesy Ben Warner.)

VIENOT'S SAWMILL, C. 1970. Wallie A. Vienot's sawmill was still in operation when this picture was taken *c.* 1970. A bulldozer connected by a pulley and belt to the saw mechanism supplied the power. At this time, it may have been considered a toy for the male enthusiast rather than a means of support. Looking up from cutting wide boards for personal use are, from left to right, Wallie A. Vienot, the owner; Arthur E. Lavoie, Vienot's neighbor and a brother to Ken N. Lavoie; Arnold L. Vienot and Harold C. Vienot, brothers of Wallie; Tom W. Beaudin, a neighbor from Southeast Road in Nepaug; and Ken N. Lavoie, husband of Wallie Vienot's niece Margaret (Vienot) Lavoie of Canton. (Author's collection.)

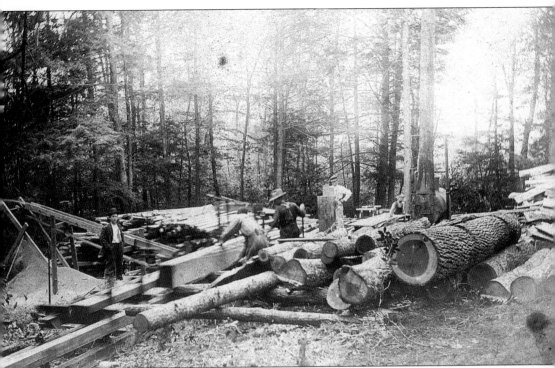

VIENOT'S SAWMILL, BEFORE 1970. At this time the sawmill was powered by steam. Located at the base of Bee Mountain on Southeast Road in Nepaug, the mill was owned and operated by Wallie A. Vienot, who had been a selectman in New Hartford from 1940 to 1965. The sawmill still stands a short jaunt uphill from the house, where the family still lives. Vienot built his house out of the lumber produced at the sawmill. There is a gravel roadway from the road to the sawmill, once used as an access route for oxen and horses. (Author's collection.)

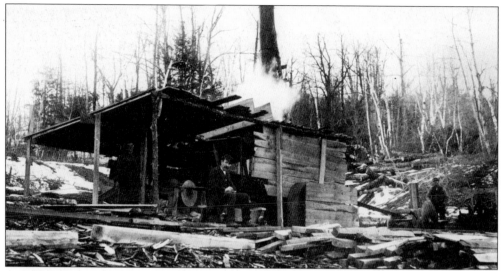

ANDERSON'S SAWMILL. A. Monnie Anderson of Nepaug owned this steam-powered sawmill captured on film in January 1905. Notice the escaping steam just above the roof. A tall smokestack rises high above the steam. Also note the large teeth of the circular saw blade directly behind Ruben Mason (seated). A second large saw blade is set up in front of the man on the right. The slope on the right holds logs ready to be cut into building material. The foreground shows different products, including railroad ties, planks, and various sizes of cut lumber. The chipped off pieces of slabs on the ground were ideal for use as kindling. (Courtesy Charles William Anderson.)

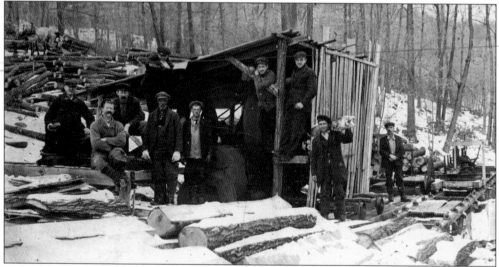

A PORTABLE SAWMILL. This steam-powered sawmill is made of two separate parts, making it portable. Oxen or horses could be hitched to the ends to pull it away to a different location. Sawmills like this traveled to the tree lots rather than the logs being hauled to the mill. In the upper right is a team of workhorses harnessed and hooked to a load of logs ready to be pulled. Most of these men are Andersons and Stedmans of Nepaug. The fourth man from the left was a pauper from Burlington. He was stationed at the Greens, who scheduled him and others to work as woodchoppers on nearby farms. The paupers were given short-term assignments in exchange for room and board provided by the town. (Courtesy Charles William Anderson.)

116

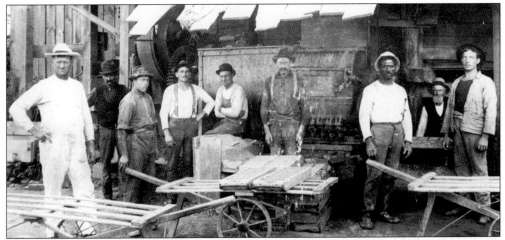

THE BRICKYARD. These men of Nepaug are taking a break to have their picture taken in their positions working at the brickyard. The large gears with long teeth are evident toward the left above the man in the white shirt and suspenders. In the center behind the two men is the oven for baking the bricks. In the foreground are three two-wheeled brick wagons, each with one handle. The center wagon is holding forms for pouring and baking the bricks. Note the different styles of hats the men are wearing. (Courtesy Charles William Anderson.)

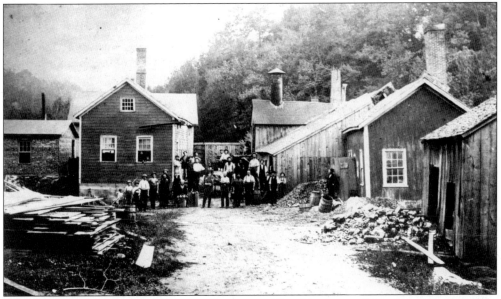

THE HENDERSON MANUFACTURING COMPANY. The Henderson Manufacturing Company started as a mill downstream along the Nepaug River at the corner of Stedman Road. A waterwheel of a 12-foot-wide canal and dam were constructed to produce water power. For 33 years the company was run under different businesses, including the A.S. Atkins Company, which transformed it into a manufacturing company, the E.S. Tribb Company, and A.S. Neal. At some time Zebulon Merrill moved his sash-and-blind factory from a former location to these buildings. James F. Henderson bought the company and ran it through the Civil War years, employing 25 men. Documentation shows that door locks, padlocks, ceramic castors, and general hardware were manufactured here. The last owner before the buildings burned in 1875 was Forbes and Clark. (Courtesy Charles William Anderson.)

DEER HUNTING. Wild game was a staple food in the Colonial period. Since then, hunting has become a recreational sport, and wild game has become a delicacy for some family tables. Gun in hand, Ben Warner, a longtime New Hartford resident now residing in Barkhamsted, and Bobby Brighenti of New Hartford have returned from hunting with a buck and a doe. The game has been dressed, and the doe is hung on a tree to season. Brighenti holds the antlers of the prize buck. (Courtesy Ben Warner.)

SMITH'S OXEN. It looks like an enjoyable summer activity, riding on Charlie Smith's ox cart over a well-trodden road in Nepaug. Smith's oxen are hooked to a double ox yolk. Note the size and shape of the yolk over the shoulders of the oxen. This demonstrates how great the load will be on one animal if the oxen are "unequally yoked," as the phrase goes. (Courtesy George Ganung.)

THE SLAUGHTERING PROCESS. Slaughtering cattle was a necessity in the Colonial days for family survival. Farmers raised beef cattle of their choice of variety. In the first half of the 1900s, many farmers produced their own meats, mainly from their own stock of beef cattle, pigs, and chickens. Some farmers chose other domestic animals. Hunting for wildlife was a very common source of meat also. Farmers would often group together to help one another slaughter their beef or game. The slaughtering and preserving of the meat was done in late fall when the weather was cold enough to hold the meat during the butchering process. After skinning the hide, the beef animal was cut into quarters. The quarters were then placed on hooks and hung for a few days to allow the meat to become tender. Pictured here on December 10, 1972, is Arnie L. Vienot of 385 Southeast Road, Nepaug, cutting a half side of beef into a quarter with a beef-cutting saw. His apprentices are Ken N. Lavoie (left), husband of Margaret (Vienot) Lavoie of Canton, and Tom W. Beaudin (center), Vienot's neighbor, of 386 Southeast Road, Nepaug. (Photograph by Francis Beaudin, author's collection.)

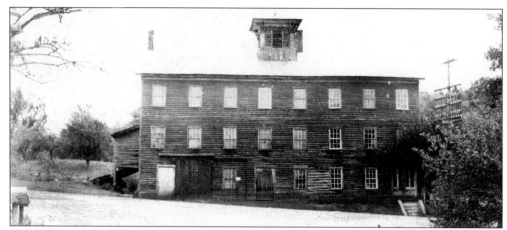

THE OLD MILL. This Old Mill is situated at the intersection of the Litchfield Turnpike and North Road in Bakerville. The original two-story structure burned to the ground in 1856 and was rebuilt in 1858 as a three-story building. It was referred to as the Tannery, but when John Baker changed it from water power to steam power, the name became the Old Mill. The building had been used for small businesses, including a sawmill, a tailor shop, a boot- and shoe-making operation, a book shop, a tannery, condensed milk production, and the preparation of a birch-flavored soft drink called Small Drinks. The new third floor was used for social activities, such as plays, shows, church socials, town political gatherings, and most favorably, a place to dance. The dance hall has a spring floor to accommodate the movement of dancing. In 1885, after Anthony Baker's death, Ai and Mary Alice (Enright) Bunnell rented the building for their sawmill business. George W. Jones (1861–1855) bought it with eight acres of land in 1889 for $525. He used it to make wood shingles and plow beams. (Courtesy Barbara [Jones] Goff.)

THE BLACKSMITH SHOP. The blacksmith shop is still standing on the corner of Litchfield Turnpike and Cotton Hill Road. It is thought to have been founded by Harry Woolmont, possibly spelled Henry Wilmot. Aaron Gates bought the shop with its buildings c. 1800 and hired Warren N. Jones, age 17, as an apprentice, who eventually took over the trade. Warren's son George W. Jones (1861–1955) lost his hearing in one ear and his dream of a music profession at age 13. He then learned the business with his father. Warren N. Jones died in 1885, and his son took over, operating it until he was 61. The shop was also used for his sideline business of making walking canes out of native hard maple and hickory. He also produced ax and hammer handles out of hickory wood. (Courtesy Charles William Anderson.)

GEORGE JONES IN HIS SHOP. This February 18, 1933 photograph shows George W. Jones heating a piece of iron in the fire on his forge. He is preparing to pound it into a desired shape on his anvil, which is pictured in the lower left. Jones made and fit shoes for horses, pony shoes with no heal or toe, and oxen shoes fashioned as two parts to fit cloven feet. At his forge and anvil, he designed multiple implements, such as doorknockers, fireplace pokers, knickknacks, chain hooks, staple pullers, wrecking bars, whiffletrees, neck yokes, and door handles. (Courtesy Charles William Anderson.)

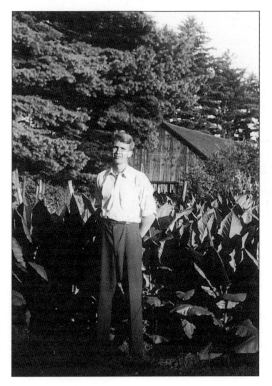

WARNER'S TOBACCO FARM. In 1944, Benjamin Warner stands among tobacco plants on the family farm called the Pike Place on Prospect Street in New Hartford. Tobacco was an enterprising crop for a farmer in the early 1900s, but it began to diminish in Connecticut shortly thereafter. The Warner farm produced Type 54 outdoor tobacco, also called Connecticut broadleaf or Connecticut seed tobacco, which was grown on many small Farmington Valley farms. This type of tobacco was used to make the filler for the center bulk of a cigar. The filler is made of shredded tobacco leaves. The second type of tobacco is the binder leaf, which must have certain qualities to be pliable for holding the filler together. The third type of grown tobacco is the wrapper leaf, seen growing throughout the Connecticut River Valley. It is grown under netting and is called shade tobacco. This type of leaf is expensive to grow and must have a good appearance for the outside of the cigar. (Courtesy Ben Warner.)

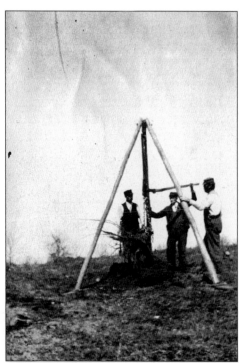

PULLING STUMPS. This is one method of pulling stumps out of the ground used on the Marsh farm on the Litchfield Turnpike in Bakerville. The men are working as a trio with a chain wrapped securely around the stump of a tree and are slowly hoisting upward until the roots tear out of the ground. Clearing a wooded area to produce a field for crops involved many laborious hours. (Courtesy Bill Stafford.)

BIG TIMBER. This is a good example of the size of timber the early settlers handled. Dot Warner admires the large pine log her husband, Ben Warner, cut on the New Hartford-Barkhamsted town line. He has it propped on an old-time sled to skid across the snow. These sleds were typically hitched to oxen or horses to haul the loads. (Courtesy Ben Warner.)

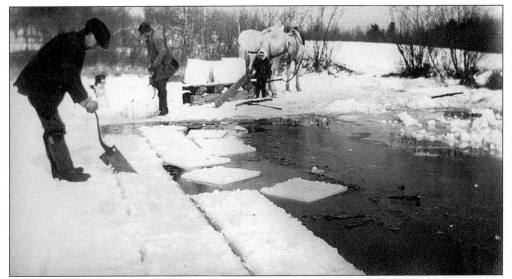

HARVESTING ICE. Ice was harvested from lakes and ponds to use during the winter and store for use through the following autumn. The man on the left is cutting the ice with a long large-toothed ice saw. The winters of the 1800s and early 1900s were much colder those of recent years. It was common for the ice to freeze 18 inches thick. The ice was cut into uniform blocks, carried away by livestock pulling a sled, and then stacked into an icehouse insulated by layers of sawdust. The blocks of ice were gripped by large ice tongs, slung over a man's back, to carry to an icebox in the individual houses. (Courtesy Bill Stafford.)

FISHING FOR SUCKERS. The men in Nepaug are having a usual fishing party on the Nepaug River. Suckers were caught by cutting a hole through the ice and lowering long rods with hooks on the bottom into the water. The boys were sent upstream to stomp on the ice of the river, sending the suckers downstream where they were hooked by the fishing tools. The suckers were reported to be large in size and good to eat. The practice seems to be unique to Nepaug. It is believed the villagers learned the skill from the Nepash Indians. Note one of the hooks can be seen in the center of the picture. Sucker fishing ceased after construction of the Nepaug Reservoir, when a weir was installed across the Nepaug River to prevent the suckers and other fish from swimming upstream. (Courtesy H.R. Edwards.)

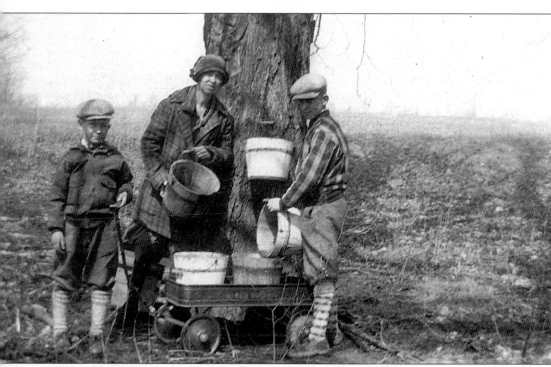

COLLECTING SAP. Nina Marsh and two unidentified boys are consolidating the buckets of sap that they collected on Maple Avenue Farm in Bakerville. The sugar maple trees were tapped by boring a taphole through the bark and filling the hole with a spout to allow the sap to run up the trunk and drop into a container attached to the tree. The tree sap rises inside the trees as winter temperatures warm, allowing it to flow out of the opening. Raw sap is a clear, thin liquid with little taste. In a sugarhouse, the sap is boiled down, eliminating most of the water and creating the pure maple syrup that has become a tradition. (Courtesy Bill Stafford.)

The Sugarhouse. The sugarhouse on the Maple Avenue Farm, owned by Elisha and Adelia Marsh, was downhill from the brick house. Its chimney is positioned in front of the roof of the brick house where Mary and Randy Auclair now live. The left portion of the photograph shows the milking barn and carriage shed of the main house. The sap was drained from the sugar maple trees and boiled down for hours to produce thick maple syrup. (Courtesy Bill Stafford.)

A Family Picnic. The Marsh family is preparing for a family picnic on their Maple Avenue Farm. On the left appears to be a hired hand. At the sawhorse is a Marsh in-law of the Bond family, using a bucksaw to cut the dried log into firewood for the picnic. Inside the sugarhouse is one of the girls sweeping. Around to the right of the sugarhouse are other women of the Marsh family, preparing the food. (Courtesy Bill Stafford.)

THE BAKERVILLE GAS STATION. The Bakerville Gas Station was on the corner of Route 202 and Maple Hollow Road. Now, there is a car repair business there and the gas pumps are gone. Burton W. Morse, who owned and operated the business, was born in New Hampshire on November 1, 1908. He was the son of William Morse and Bell (Spencer) Morse, who grew up on West Road in Nepaug. Burton Morse was the proprietor of the gas station during the first half of the 1900s. He married Beatrice Hudson, born June 17, 1914, and they lived at 972 Town Hill Road at the intersection of Route 202, where they raised their four children. He passed away in August 1998. (Courtesy Ralph and Judy Morse.)

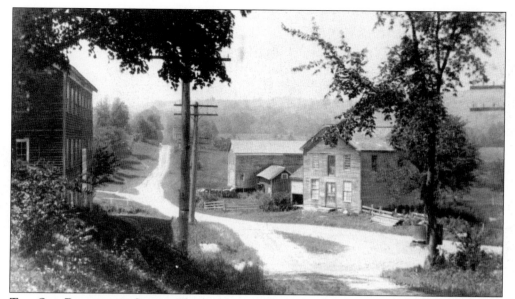

THE OLD BAKERVILLE STORE. The building on the right was the general store of the past. It was across from the Old Mill (left). For a location reference, note the Old Mill, shown on the left at the intersection of Litchfield Turnpike (now Route 202) and North Road (now Cedar Lane). The road heads in the direction of Torrington. Anthony Baker managed the old store from 1837 to c. 1855. He gave a house to his daughter Isabelle A. Baker and her husband, Sylvester Pettibone, across the road. With the home, they received the property occupying the old general store. Isabelle and Sylvester gave the store the name Pettibone's General Store. (Courtesy Charles William Anderson.)

THE MAPLE HOLLOW GRISTMILL. Going down the hill on Maple Hollow Road, past the intersection of Dings Road and directly over the bridge, on the left side is a gristmill perched on a high stone foundation above the brook. Joe Gillette (1778–1857) was the founder of the mill. It is said to be the only surviving internal-powered mill in the state. Gillette also had sawmills and carding machines. He lived in the next house down on Maple Hollow Road, known now as Johnny Phillip's home. Members of the Gillette family operated the gristmill until 1892. (Courtesy Douglas E. Roberts.)

THE AUTHOR. Margaret L. Lavoie is the author of *Images of America: New Hartford*, published by Arcadia Publishing, which produces the *Images of America Series* nationwide, making local history available to countless communities and individuals. Margaret Lavoie has diligently researched historical records, interviewed people, and compiled pictures to write this book. Her daughter Lisa L. Hewett of Andover orchestrated the editing and the picture scanning. Her other daughter, Renee J. Lavoie of Glastonbury, was instrumental in word processing. Her husband, Kenneth N. Lavoie, gets credit for being supportive in handling all the responsibilities of the home. The picture owners were dedicated in giving time and their wealth of information to develop this book. Margaret Lavoie grew up in New Hartford and graduated from Bakerville Consolidated School and Northwestern Regional High School. Her interest in the people and her fascination with her father's stories gave her a sound background to compile this wide overview of New Hartford.